Knockouts

A Pocket Guide

Sally Ruth May

Design: Thomas H. Barnard III
Editing: Jane Takac Panza, with
Barbara J. Bradley, Laurence Channing, Henry
H. Hawley, Kathleen Mills, Katharine Lee Reid,
and Katherine Solender
Photography: Howard T. Agriesti and
Gary Kirchenbauer
Imaging: Janet Burke and David Brichford
Production: Charles Szabla
Printing: Watt Printers
Composed in Adobe Palatino

ISBN: 0-940717-69-7
Library of Congress Control Number:
2002101655

Cover: George Bellows (American, 1882–1925).
Stag at Sharkey's, 1909 (detail). Oil on canvas;
36¼ x 48¼ in. Hinman B. Hurlbut Collection
1133.1922

The Cleveland Museum of Art wishes to thank
the following for permission to reproduce
works in this volume:
ARS: 62, 64, 67, 123
Anselm Kiefer: 66
Thomas Struth: 124
VAGA: 65, 121
Nancy Youngblood: 114

NATIONAL
ENDOWMENT
FOR THE ARTS

This publication is supported in part by an
award from the National Endowment for the
Arts.

Contents

Introduction

The Cleveland Museum of Art, one of the world's great art museums, holds some 40,000 works of art in trust for the public. The museum's historic preference for quality over quantity has kept the collection relatively small, especially compared to the voluminous holdings of some of Cleveland's international peers. To the visitor, the happy result is a museum that is both comprehensive in scope and comprehensible in scale. Still, after 85 years of energetically collecting works of art from all times and cultures, the museum's holdings have inevitably become numerous and complex. That complexity has given rise to this publication, which seeks to provide a representative selection of the treasures that reside here.

This handbook points out key works in all of the museum's collections, both to identify and describe some of the greatest masterpieces in the museum and to provide fruitful starting points for the visitor's further exploration. In all, some 130 works of art are illustrated and briefly discussed here.

The organization of this handbook reflects the chronological flow of the galleries, so that one may use it as a guide while exploring the museum in person or refer to the text and illustrations when away from the museum. For those using this guide to browse the galleries, I recommend picking up a museum map in the main lobby or from one of the gallery kiosks located around the museum.

The highlights of Western art begin in the ancient Near East, Egypt, Rome, and Greece, and progress through medieval and Renaissance Europe, 18th- and 19th-century European and American art, Impressionism, and Modernism, concluding with a few works from our own time. The distinguished collection of Asian art includes works from China, Japan, Korea, India, the Himalayas, and Southeast Asia. Smaller collections of the art of the ancient Americas and African art are also included.

We hope the information about these 130 works of art will invite your further exploration and enjoyment of the museum's splendid collection.

Welcome!

Katharine Lee Reid, Director

Ancient Near East

The museum's Ancient Near Eastern collection represents the cultures that flourished in the areas of the Middle East, Caucasus, and Western Central Asia between the 4th millennium BC and early 1st millennium AD. Highlights include the silver vessels made for the Sassanian kings of Iran (300s–400s AD), an imposing wall relief from the palace of the Assyrian king Ashurnasirpal II (about 870 BC), and a surprisingly modern-looking statuette of a female figure from Turkey (about 3000 BC).

1 More than 5,000 years ago in what is now modern Turkey, preliterate Stone Age sculptors carved small, highly simplified female forms that we can only suppose were funerary figures or cult objects. Today, these figures are called "stargazers" because their oval heads tilt back

1 *"The Stargazer,"* about 3000 BC Probably from western Anatolia

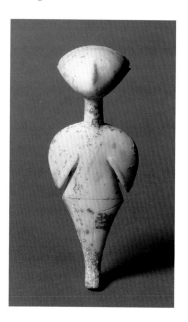

so that their tiny eyes stare up toward the sky. **The Stargazer** is among the oldest sculptures of the human figure in the museum's collection. She still retains remnants of dirt and minerals from being buried in the ground for thousands of years. The simple, pure form and subtly shaped surface of figures like this influenced early 20th-century masters.

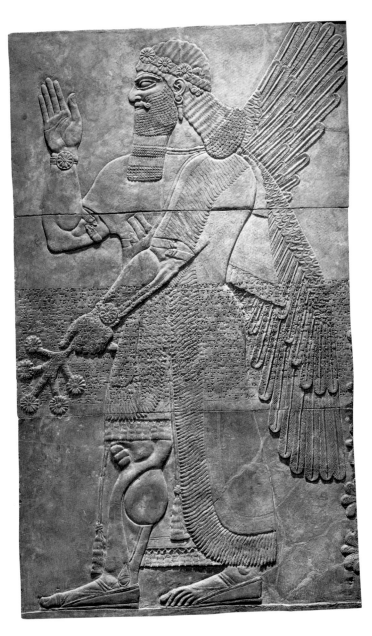

2 *Winged Genie,*
875–860 BC
Iraq

2 During the 9th century BC, the vast new palace of the Assyrian king Ashurnasirpal II in present-day Iraq was decorated with huge stone reliefs that functioned like modern-day propaganda posters. Their intent was to awe the visitor with scenes of the king at war or on hunts, but they also depicted the ruler performing various rites in the company of supernatural beings. This relief portrays a larger-than-life-size **Winged Genie,** or protec-

tive spirit, who sprinkles pollen from a flowering date palm. A cuneiform inscription boasting of the king's conquests runs through the center of the intricately patterned relief. The text states, among other things, that the new palace was built by prisoners of war.

3 Among the museum's treasures is a remarkable collection of silver-gilt vessels from the powerful Sassanian dynasty (about AD 224– about 650). Using silver mined from their own territories, the Sassanians produced this royal hunting **Bowl** depicting Hormizd II or Hormizd III hunting lions, symbols of royalty. The elaborately crowned king performs remarkable feats of archery and horsemanship.

3 *Bowl*, AD 400–600
Iran

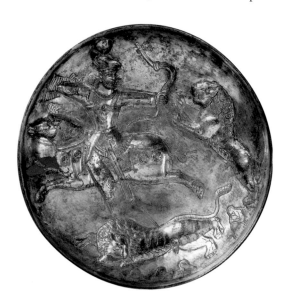

Egypt

The collection represents all periods of Egyptian art from prehistoric times (about 3500 BC) to the Roman occupation of Egypt (about 50 AD). Particular areas of interest include the elegant statuary and decorative arts of King Amenhotep III (about 1390 BC), the highly refined sculpture of the Egyptian Late Period and Greco-Roman Period (700 BC–50 AD), and an extraordinary group of painted wooden mummy cases from around 1000 BC.

4 *Statue of Amenemhat III,* 1859–1814 BC Egypt

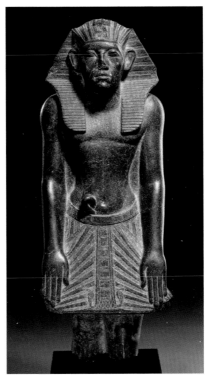

4 Portrait sculpture was the chief glory of Egyptian art during the long, prosperous rule of Amenemhat III (1859–14 BC). Although this **Statue of Amenemhat III** bears no inscription, the pharaoh's distinctive facial characteristics —high cheekbones, hollow cheeks, and jutting lower jaw—are unmistakable. Wearing a royal headdress and short ceremonial kilt, Amenemhat III strides forward with his left leg advanced in the classic Egyptian pose. His body also conforms to a trim, muscular, broad-shouldered, narrow-hipped ideal. The sculpture shows the all-powerful, stern-faced ruler in an attitude of worship—appropriate for a temple statue.

5 *Head of Amenhotep III Wearing the Round Wig,* 1391–1353 BC Egypt

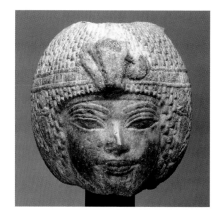

5 Ancient Egyptian civilization witnessed its greatest splendor during the reign of Amenhotep III (1391–53 BC), a great patron of the arts. The **Head of Amenhotep III Wearing the Round Wig** was carved from brown quartzite, one of the king's favorite stones. He wears an elaborate headdress consisting of a tightly curled wig adorned by a diadem. Although the statue probably dates from the last part of Amenhotep III's reign, his exotic features appear almost baby-faced. The portrait was probably

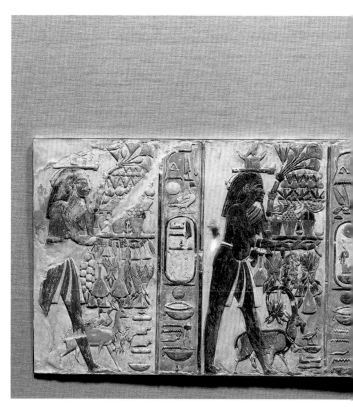

made to celebrate the renewal of Amenhotep III's kingship in a festival that occurred after his 30th year on the throne. Thus, Amenhotep III—who may have been as old as 50—appears as an idealized infant, physically reborn through the statue and ritually reborn in his kingship.

6 These remarkably preserved blocks from a temple wall relief are the finest to survive outside Egypt from the splendid reign of Amenhotep III. Four figures representing **Nome Gods** bear lavish food and other offerings representing the bounty of their provinces (nomes), identified by the emblems above their heads. Drawn with striking naturalism and fine detail, the nomes bring their gifts to Amenhotep III, who presents them to an unknown god, whose two large feet are shown in the fragment above. The brilliant colors are all original, probably because the blocks were protected when later used in the foundation of another building.

6 *Nome Gods,* 1391–1353 BC Egypt

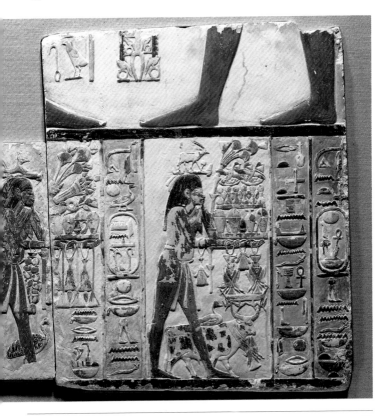

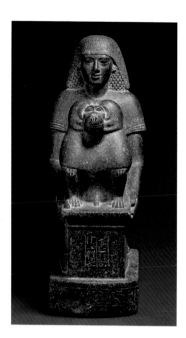

7 *Statue of Minemheb, 1391–1353* BC *Egypt*

7 No other image of the high official Minemheb survives today. The hieroglyphic inscriptions on the **Statue of Minemheb** reveal that he was a court official who managed the construction of a special festival hall for the ritual celebration of Amenhotep III's 30th year of reign (1391–53 BC). Amenhotep III may have presented this statue to Minemheb in return for his services. A statue within a statue, the sculpture shows Minemheb kneeling and holding an altar. Squatting on top of the altar is a serene, almost smiling baboon representing Thoth, the god of wisdom and patron of scribes like Minemheb. The statue probably stood in a temple dedicated to Thoth as a sign of Minemheb's eternal devotion to the baboon-headed god of writing.

8 For the ancient Egyptians, coffins not only protected their owners in death but also helped to bring about their rebirth in the afterlife. Consequently, coffins grew ever more elaborate, culminating with those made between the 11th and 10th centuries BC, as in the **Coffin of Bakenmut.** This large, lavishly decorated coffin was made for the priest Bakenmut. The priest appears on the cover—his arms crossed in the traditional pose of death—and on the interior, wearing a luxurious panther skin and making offerings to various gods. The painted religious scenes that cover every available surface depict spells, magical symbols, and funerary gods and goddesses that would help Bakenmut's spirit attain an afterlife of eternal bliss.

8 *Coffin of Bakenmut, about 1000–900* BC *Egypt*

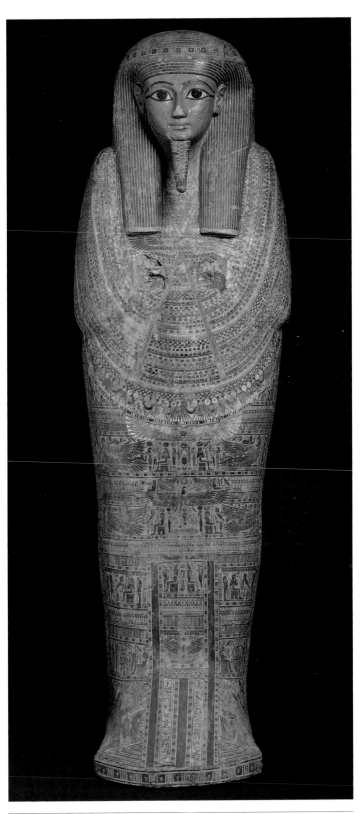

Greece and Rome

The collection of antiquities from ancient Greece and Rome numbers about 450 works from Greece, Etruria, Rome, South Italy, Cyprus, Crete, and Sardinia, and from Neolithic and Bronze Age Europe. These include examples of marble, bronze, and terracotta sculpture, painted vases, jewelry, and coins. The collection spans about 4,000 years, demonstrating the creativity and diversity of these ancient European cultures.

9 This subtly modeled marble torso was once part of a full-length, freestanding, brightly painted statue called a **Kouros** (Greek for male youth). Its frontal posture and slim, broad-shouldered proportions reveal Egyptian influences. However, the nudity and the absence of a pillar to support the figure from behind are

9 *Kouros,*
575–550 BC
Greece

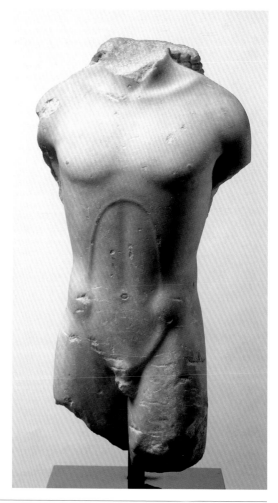

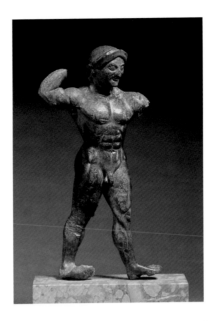

10 *Statuette of an Athlete*, 510–500 BC Greece

Greek innovations. Expressing an ideal of masculine physical perfection, *kouroi* stood at gravesites or at cult temples as dedications to the gods. Made only from the late 7th through the 6th centuries for wealthy patrons, few are known today. Now these kouroi are seen as prototypes of the figure in Western art.

10 Between 510 and 500 BC, when this bronze **Statuette of an Athlete** was made, Greek sculptors moved toward a revolutionary breakthrough in the naturalistic rendering of the human figure that would determine the future of all European art. With its striding pose and raised arm, the statuette demonstrates this sculptural achievement as clearly as any surviving sculpture in the round. The figure's nudity, muscular physique, short hair, and distinctive pose indicate that it once represented an athlete (probably a javelin thrower) and may have been dedicated by a victor to the gods at a Greek sanctuary. The figure's stocky, well-defined musculature recalls the sculptural styles of the Peloponnesus, the southern part of Greece.

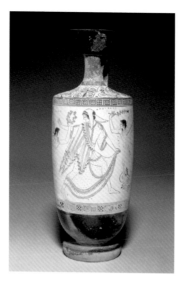

11 *The Atalanta Lekythos,* 500–490 BC
Attributed to Douris

11 Vase paintings are almost all that has survived of ancient Greek painting. The exquisite drawing and extraordinary condition of the **Atalanta Lekythos** (olive oil jug) make it one of the finest white-ground vases in existence. The decoration is painted on a fragile white background of thin slip (a diluted clay mixture). The beautifully composed scene on this jug depicts the mythological princess Atalanta chased by Erotes (Greek "cupid" figures) as she challenges her suitors to outrun her. The painting is attributed to Douris, one of Athens' most important vase painters of the early 5th century BC. White-ground *lekythoi* were used as tomb offerings, which may account for this example's pristine condition.

12 *Red-Figure Squat Lekythos,* about 410 BC
Attributed to the Meidias Painter

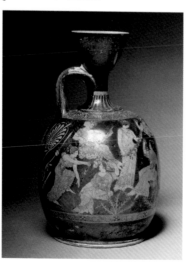

12 The Meidias Painter decorated this **Red-Figure Squat Lekythos** (olive oil jug) around 410 BC, just before Sparta's final defeat of Athens in the decisive Peloponnesian War (431–404 BC). Yet the vase portrays an elegant, mannered world that reveals nothing of that dire time. Instead, in a celebration of hometown pride, the Meidias Painter depicted the birth of Erichthonios, an early legendary king of Athens, who, according to tradition, was born from Ge (Earth) and raised by the goddess Athena, patroness of Athens. In the red-figure technique the unpainted clay is red, reserved for the figures; imagery is defined by painting with liquid clay that turns black when fired. This elegant vase is also embellished with gilded relief.

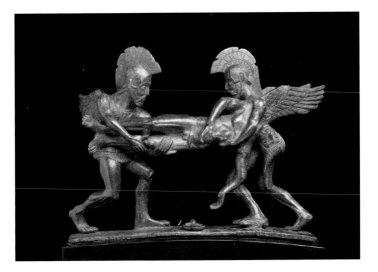

13 *Cista Handle,*
400–375 BC
Italy

13 Made in the early 4th century BC, this small **Cista Handle**—the handle from the lid of a jewelry box—attests to the Estrucans' mastery of casting bronze. Its intricately detailed figures were cast separately and seamlessly joined together. For their subjects, these ancient inhabitants of what is now modern Tuscany often borrowed from Greek myths and legends. In what may be an incident from the Greek epic poem *The Iliad* by Homer, the twin winged brothers, Sleep and Death, lift the corpse of the Lycian warrior Sarpedon, son of Zeus, from the bloody Trojan battlefield to carry it home for burial. The Etruscan version of this Greek theme is one of the most touching in Western art.

14 This imposing statue of the **Emperor as Philosopher** is among the finest large bronze sculptures to have survived the Greco-Roman age. The figure's pose, freshly pressed drapery (a sure sign of wealth), and traveler's sandals suggest that the statue represents Marcus Aurelius, the revered 2nd-century emperor-philosopher (reigned AD 161–180). The Greeks may have developed the philosopher type of statue—the draped male figure with one arm relaxed, one raised—but the swirling folds of fabric around the hand are Roman innovations. The statue was assembled from 29 separately cast pieces joined together to create the illusion of a unified whole. Damage marks suggest the head was forcibly removed in antiquity. Nonetheless, the statue still projects an aura of authority and quiet contemplation.

14 *The Emperor as Philosopher,* about AD 175–200 Turkey

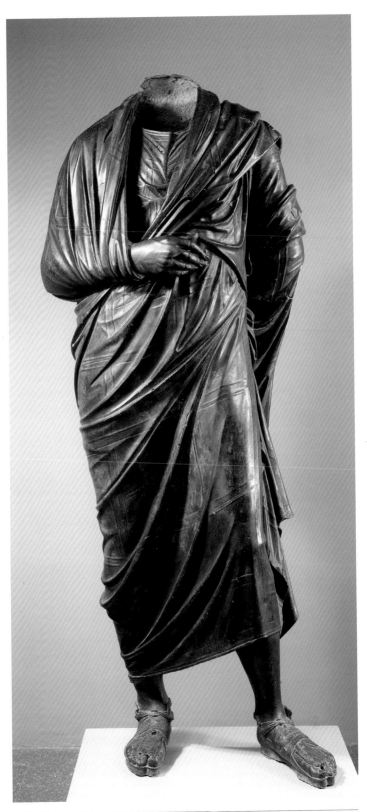

Early Christian and Byzantine

Although modest in size, the collection of Early Christian and Byzantine art contains choice material dating principally through the end of the Middle Byzantine period (1204). Notable objects range from the unique *Jonah Marbles* from the 3rd century AD to the ivory *Plaque with the Enthroned Mother of God* made after AD 843, and together capture the essence of the Early Christian and Byzantine worlds at their peak of artistic creativity.

15 Christianity spread rapidly throughout the Roman Empire, and by the 3rd century an art based on Greco-Roman tradition and rich biblical imagery had evolved. Archaeological evidence suggests that these rare sculptures, found buried together in a large storage jar, were designed for a fountain in the garden of a Christian home. Known as the **Jonah Marbles,** they combine Hellenistic figure types—sea monsters and river gods common in Greek Mediterranean culture—with Roman portraiture to tell the Old Testament story of Jonah swallowed and cast up by the whale. For Christians of this era the popular Jonah story symbolized the crucifixion and resurrection of Christ, the Good Shepherd. Tests prove the group was carved from the white-grained marble found in central Turkey.

15 *The Jonah Marbles,* AD 270–80 Eastern Mediterranean, probably Asia Minor

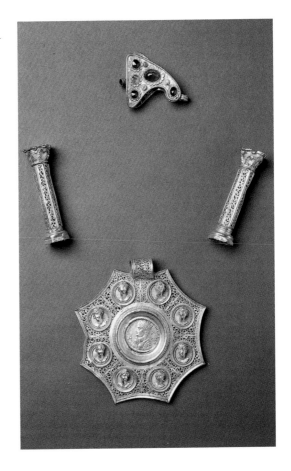

16 This octagonal pendant, two column-like spacers, and clasp were once part of a splendid gold necklace created during the era of Constantine the Great (reigned AD 306–337). The centerpiece of the **Constantine Necklace** was probably the octagonal pendant featuring a coin with the emperor's head surrounded by exquisite openwork and eight tiny three-dimensional busts. On the reverse were portraits of the ruler's sons and an inscription indicating that the coin was struck on New Year's Day, AD 324, to commemorate their third consulship. Such a magnificent necklace was probably an imperial gift to a member of the emperor's family or an important political supporter.

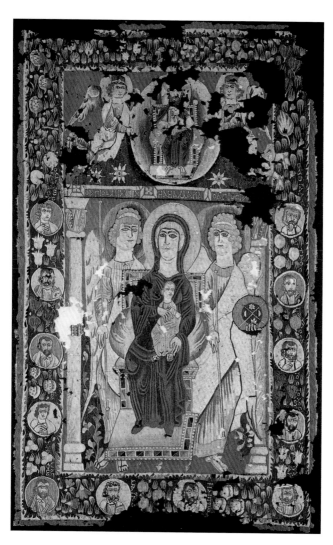

17 *Icon of the Virgin*, 500s
Egypt

17 This large, richly colored tapestry is the only textile icon known glorifying the Virgin Mary as the Mother of God (*Theotokos*). Probably made in Egypt in the 6th century, the **Icon of the Virgin** portrays Mary seated on a jeweled throne holding the Christ child in a majestic setting borrowed from imperial Byzantine art. Archangels Michael and Gabriel, identified above in Greek, flank them. Above, Christ appears in an aureole of light supported by angels in the starry heavens. Portraits of apostles and evangelists, also identified in Greek, appear in the surrounding wreath of fruits and flowers symbolizing eternal life. Presumably this luxurious portable icon was hung in a place of worship, such as a church or private chapel.

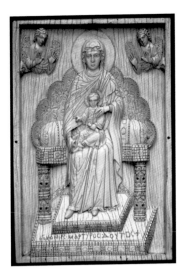

18 *Plaque with the Enthroned Mother of God, about 1050–1200 Byzantium*

18 In the period after the iconoclastic purge of religious images (AD 726–843), the frontally posed Virgin and Child was the most popular type of image found in sacred apses, or niches, of Byzantine churches. This small, delicately carved portable **Plaque with the Enthroned Mother of God** with the Christ child was used for private devotion. The direct gaze of the sacred figures—so characteristic of Byzantine art—invites immediate communication with the worshipper. This type of icon with the Virgin and Child on a throne is also known as the *Nikopoios* or "Victory Maker," believed to protect Constantinople from invasion when carried into battle.

Medieval Europe

The medieval collection of the Cleveland Museum of Art consists of works produced in continental Europe, the British Isles, and the eastern Mediterranean basin during the period spanning the 3rd century AD through the early 1500s. Included here are works of art produced in a variety of materials, techniques, and styles, gathered largely as a collection of masterpieces rather than as an attempt to illustrate the whole of medieval culture.

19 This gem-encrusted golden **Portable Altar,** owned by Countess Gertrude, wife of Liudolf of Braunschweig, Germany, was used to celebrate Mass in her private chapel or when she traveled. There are still relics inside. With the embossed gold figures, rich cloisonné enamel, and intricate gold filigree, the altar and the two **Ceremonial Crosses** reveal the mastery of German goldsmithwork during the 11th century. Gertrude donated the altar and crosses to a church she had founded in Brunswick, a thriving city in Lower Saxony. Later this precious gift became part of the Guelph Treasure, one of the most famous ecclesiastical treasuries (collections of precious objects in a church) of the Middle Ages.

20 Painted wooden panels shaped like a crucifix hung in nearly every church in Italy from about AD 1000 to 1350. Made before 1250, this rare, excellently preserved **Crucifix** is one of the earliest panel paintings in the museum's

19 *Portable Altar and Ceremonial Crosses,* about 1038–45 Germany

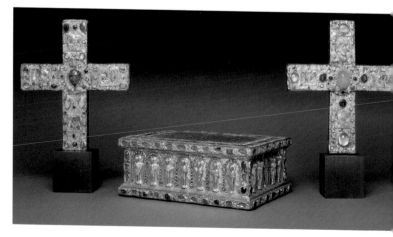

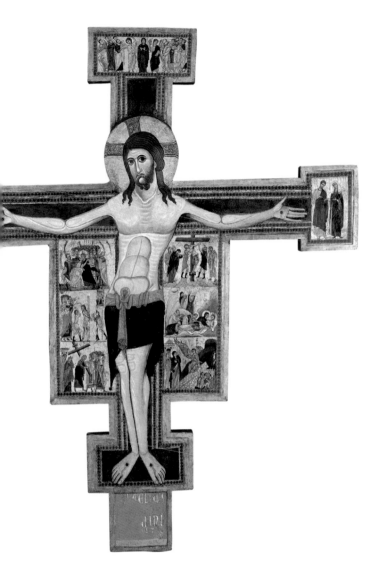

20 *Crucifix*, about 1230–40 Italy

collection, a painted cross that shows Christ very much alive, his open-eyed defiance a premonition of his Resurrection. The figure's stylized depiction reflects eastern Byzantine influence, but its nearly life-size stature is an Italian innovation. Surrounding Christ are six Passion scenes, detailing events before and after the Crucifixion.

21 This poignant wooden sculpture of **Christ and Saint John the Evangelist** depicts the tender scene at the Last Supper as described in the Gospel of John when the apostle John, "whom Jesus loved," was leaning close to the breast of Jesus. While the figure of Christ is somewhat

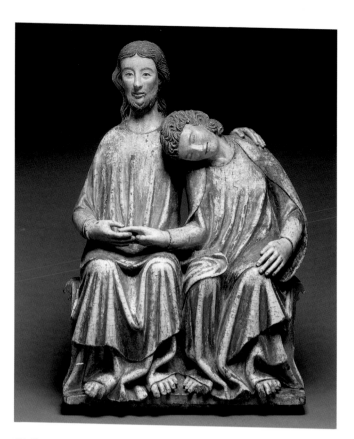

21 *Christ and Saint John the Evangelist,* early 1300s Germany

remote, there is a sweetness in the face of young St. John, with his quiet smile and blushed cheeks. Made in Germany around 1300, the exceptionally well-preserved sculpture would have stood on an altar in a side chapel of a church.

22 Once the center of attention on the table of a princely home, this delightful object is the only complete **Table Fountain** known to have survived the Middle Ages. Made of gilded silver and adorned with enameled plaques, the fountain suggests a miniature Gothic structure, complete with parapets, vaults, pinnacles, and traceried arches. A pump beneath the table forced scented water up through the central column and out the gargoyles' mouths, causing the water wheels to turn and the bells to ring. The fountain originally had a basin to catch the cascading water for recirculation. Financial need, changing taste, or war may have caused other objects of this kind to be melted down.

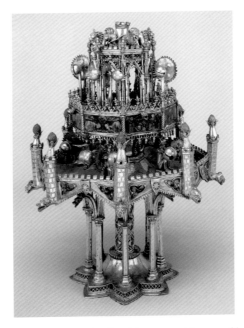

22 *Table Fountain,*
about 1300–1350
France

23 Charles V (1364–80)—a great lover of books who established an extensive royal library—may have commissioned this manuscript. Called the **Gotha Missal,** the beautifully hand-written book contains instructions in Latin for a priest celebrating Mass. It was probably used by the king's private chaplain and housed in the king's private chapel at the palace of the Louvre. Poignant, minutely rendered religious scenes in jewel-like colors accompany the text. They were made by an important Parisian workshop around 1375 and reflect the era's refined court style. *The Gotha Missal* takes its name from its 18th-century owners, the German dukes of Gotha.

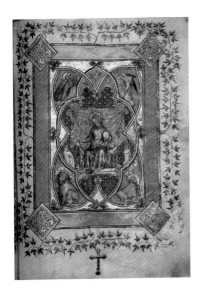

23 *The Gotha Missal,* about 1375 France

24 In this painting of the **Death of the Virgin** by the Bohemian artist known as the Master of the Holy Cross, Christ's disciples surround the Virgin Mary on her deathbed. The artist enlivened the scene with such realistic details as the disciple in the lower left who adjusts his glasses to read. Adorned in a papal

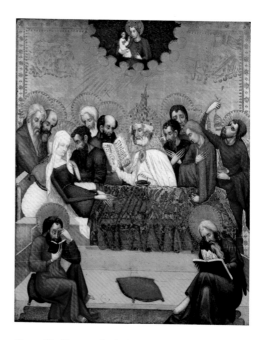

tiara, St. Peter administers last rites, while the Virgin's soul, shown as a child in God's arms, ascends to heaven against a rich gold background patterned with punchwork, or deco- rative indentations. The gold punchwork, naturalistic details, and elegant, thin hands characterize the refined international style seen in paintings made throughout Europe around 1400.

25 These **Three Mourners** joined 38 others to form a funeral procession in stone that wrapped around the elaborate tomb of the Duke of Burgundy, Philip the Bold (1342–1404), near Dijon, France. The figures were meant to represent actual mourners at the duke's

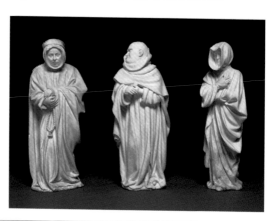

funeral—clergy, courtiers, family, even the duke's butcher. The Netherlandish sculptor Claus de Werve carved these three alabaster statuettes, giving each remarkable individuality. Thus, drapery, posture, physiognomy, and, above all, expressions of grief vary in all of the mourners. Among the finest sculptures produced during the Middle Ages, the figures seem to mourn for eternity for one of the era's great patrons of the arts.

26 Originally, this **Madonna and Child** was one of four sculptural reliefs produced to adorn the ciborium, or marble canopy, that stood above the high altar of one of Rome's greatest churches, Santa Maria Maggiore. Italian sculptor Mino del Reame carved large, projecting figures against an empty background to ensure the relief could be best viewed from below. He

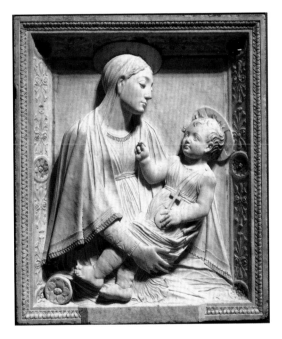

26 *Madonna and Child*, about 1461–75 Mino del Reame

was commissioned by Cardinal Guillaume d'Estouteville, who, as archpriest of Santa Maria Maggiore, was in charge of erecting the church's ciborium. Although the figures themselves appear somewhat stiff, their delicate features and flowing garments are beautifully carved, as is the frame, which still retains traces of gilding.

27 Between about 1480 and 1550, a group of prolific Flemish artists produced lavish illuminated manuscripts for such aristocratic patrons as Queen Isabella the Catholic of Spain (1451–1504), whose coat of arms appears on the frontispiece of this book of hours. The queen would have used the prayer book—probably a diplomatic gift—for private devotion at different times of the day. Alexander Bening painted the majority of the exquisitely rendered illuminations. Their decorative borders filled with naturalistic, colorfully painted flowers, birds, and butterflies characterized Flemish illuminations of the period. The **Hours of Queen Isabella** represents a peak in the art of manuscript illumination, soon to be eclipsed by the advent of movable type and woodblock printing.

27 *Hours of Queen Isabella,* about 1497–1500 Alexander Bening and Associates

European Painting

European paintings dating from the Middle Ages to 1945 constitute an important part of the museum collection, with many famous works included. Especially notable are the holdings of early Italian, Netherlandish, Baroque, and Impressionist pictures.

Baroque and Later Decorative Art and Sculpture

Included under Baroque and Later Decorative Art and Sculpture are all three-dimensional works of art made in Europe and America after 1600, with the exception of modern and American sculpture. Ceramic, metal, glass, stone, and wood objects make up the holdings. The collection is particularly rich in French decorative arts from the late 17th century to the end of Napoleon's empire in 1815.

American Art

The museum's collection of American paintings and sculpture is not large, but it nicely represents the development of American art from colonial times to the present. The collection contains colonial portraits; landscapes of the Hudson River school; paintings from the post-Civil War period, including works by Winslow Homer, Thomas Eakins, and Albert Pinkham Ryder; and modernist and Realist paintings of the 20th century, such as a group of seven paintings by Georgia O'Keeffe (four of which were donated by the artist).

28 This intimate family scene by the Renaissance master Filippino Lippi represents an unrecorded encounter between the Christ child and his cousin St. John the Baptist. St. Joseph looks on as protector of **The Holy Family** as St. Margaret presents John to Christ. The monumental, triangular form of the Virgin Mary dominates and stabilizes the composition. Behind them is an Italian landscape and unidentified city, placing the scene in the present for 15th-century viewers and worshipers. The cross is an attribute of John the Baptist, who carried it as he preached, foretelling the coming of Christ. *The Holy Family* is painted within a round format, or *tondo,* a popular shape in Italy in the 1400s and 1500s for paintings in private rather than church settings.

28 *The Holy Family,* about 1495
Filippino Lippi

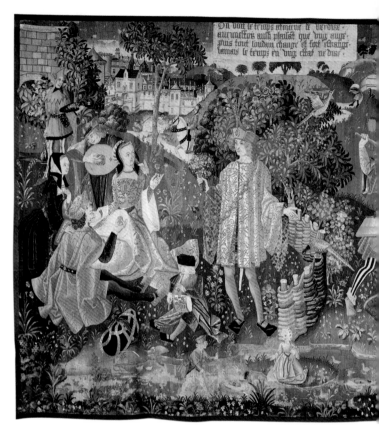

On doit le temps...
[illegible medieval French inscription]

29 *Time*, 1500–1510
France

30 *Ewer*, 1540–67
France

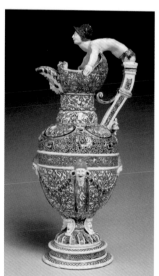

29 The elegantly clad, allegorical figure of **Time** stands in the center of this richly colored tapestry—one of four believed to have been commissioned around 1500 by prominent court noble Charles II d'Amboise for the Loire Valley Château de Chaumont (pictured above on the left). Alluding to the inevitable impermanence of life are figures representing the pleasures of youth (on the left) and the sorrows of old age and ruin (on the right). All four tapestries—three of which belong to the museum—have similar allegorical themes inspired by the *Trionfi (Triumphs)* of the Italian poet Petrarch (1304–1374).

30 This **Ewer** (pitcher) is one of the rare surviving pieces of the French Renaissance pottery made at the village of St.-Porchaire, recognized for its fine, white,

earthenware clay. The fragile artistic ware was always produced in the same manner. While still moist, metal punches impressed intricate patterns into the soft, cream-colored body. The designs were then filled in with clays of contrasting colors—mainly brown, red, black, blue, green, and yellow. For the pitcher, applied masks, frogs, and the whimsical half-human figure that forms the handle add the final decorative touch.

31 **The Sacrifice of Isaac** provides a fascinating window into the working methods of the Italian Renaissance master Andrea del Sarto. Commissioned by Francis I of France (reigned 1494–1547), the large unfinished panel depicts the dramatic moment when an angel sent by God stops Abraham from obeying God's command to sacrifice his son, Isaac. Parts of the artist's initial sketch are visible throughout the picture—the figures, drapery, and a donkey at the far right—as are pentimenti (revisions), which show the artist attempted to reposition the angel. Evidently dissatisfied, he abandoned this painting, but completed two other versions, one in Madrid and a final version in Dresden.

31 *The Sacrifice of Isaac*, about 1527 Andrea del Sarto

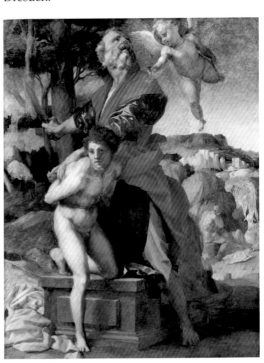

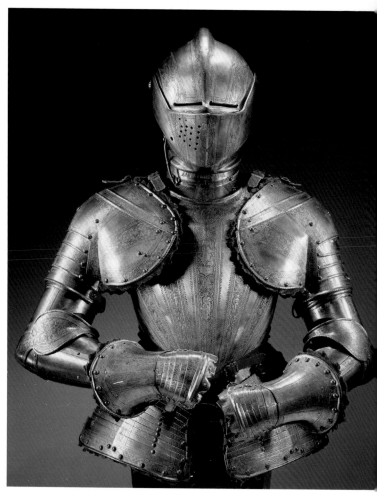

32 *Half-Armor,*
about 1590
Pompeo della Cesa

32 European armor reached its pinnacle of quality between 1450 and 1650 during the Renaissance, when this splendid etched and gilded **Half-Armor** was custom-made. Pompeo della Cesa, one of the last great master armorers in Italy, designed it specifically for a foot tournament, a contest fought with blunted swords over a waist-high fence. The armor displays Pompeo's signature style of etched and gilded vertical decorative bands, which resemble embroidery found on fashionable male doublets of the day. The original owner would have probably chosen this particular decoration from one of Pompeo's pattern books. Colorful puffed britches and hose and perhaps a bright plume on the helmet would have added the final touches to the ensemble.

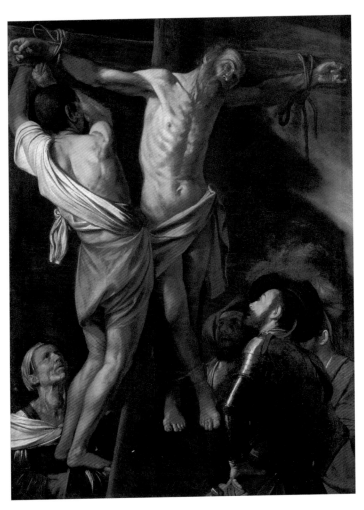

33 *The Crucifixion of Saint Andrew,* 1609–10 Caravaggio

33 The Italian artist Caravaggio captured the miraculous death of Christ's first disciple in the **Crucifixion of Saint Andrew**. Andrew was granted his wish to die on the cross: the man on the ladder was struck suddenly with paralysis in the act of reaching up to untie him. Caravaggio conveyed this miracle through the stunned expressions on the faces of his humble, realistically depicted onlookers, who are packed into a compressed space. Sharp contrasts of light and shadow reinforce the drama. The work was painted for the Spanish viceroy of Naples shortly before the artist's death.

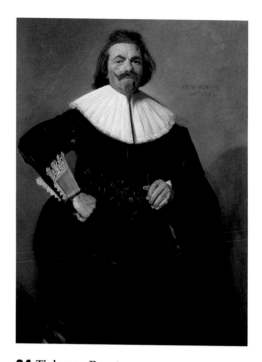

34 Tieleman Roosterman, a prosperous Haarlem merchant of fine linen and silk, exudes self-confidence in this vibrant portrait painted at the height of Frans Hals's career. The 17th-century Dutch master used a low vantage point so that Roosterman looks down at the viewer. He is outfitted in fashionable dress, with the large beaver hat in his right hand propped confidently on his hip. Hals's acclaimed virtuoso brushwork reinforces Roosterman's powerful presence, giving the immediacy of something glimpsed quickly—as if the merchant has paused casually before dashing off to another place.

35 Virtually ignored until the 20th century, French artist Georges de La Tour is now celebrated for his naturalistic, dramatically lit night scenes. In **Saint Peter Repentant** of 1645, La Tour depicted the saint at the horrified moment of recognition that he has indeed denied knowing Christ three times before a rooster crowed at dawn, just as Christ had foretold. Light from the cone-shaped lantern illuminates the clasped hands and anguished, tear-stained face of the elderly saint, as well as the beautifully rendered cock. The boldly simplified forms and sober palette enhance the impact of

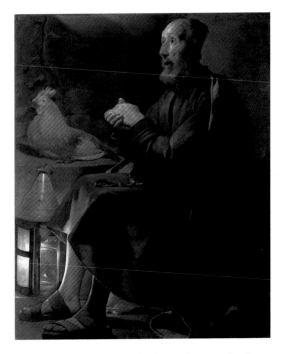

35 *Saint Peter Repentant*, 1645 Georges de La Tour

the scene. The museum's picture is one of only two paintings signed and dated by this artist known today.

36 *Baptism of Christ*, designed 1645/46 Alessandro Algardi

36 To gain papal favor, the Italian sculptor Alessandro Algardi presented a silver sculpture of the **Baptism of Christ** to Innocent X (reigned 1644–55), whose family later gave it to the king of Spain. It is now lost. The design of this bronze sculpture can be recognized from contemporary documents as similar or identical to that of the silver group. Furthermore, the figures are clearly modeled in the personal style of Algardi. When earlier sculptural groups were created, the figures were usually closely united. Here, Algardi has chosen to separate them spatially, but join them through the complementary poses of the larger figures and the flying putto, who is suspended between them. The drama of an event of great importance has been captured for all time in bronze.

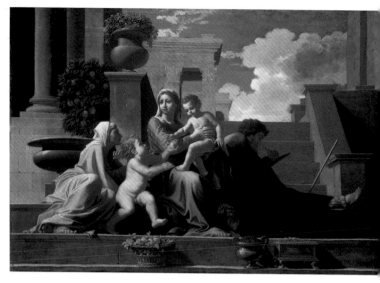

37 *The Holy Family on the Steps*, 1648 Nicolas Poussin

38 *Blessed Alessandro Sauli*, 1663–68 Pierre Puget

37 **The Holy Family on the Steps** is among the French artist Nicolas Poussin's most important mature works. Painted in 1648 in Rome, where Poussin worked for most of his life, it reflects his love of classical antiquity and the masters of the Renaissance. Every aspect of the painting re-inforces its theme of salvation and redemption. The composition is rigorously ordered into a simple monumental triangle of idealized figures consisting of carefully balanced shapes and colors. In luminous blue and red, Mary towers above, enthroned as the queen of heaven who presents Christ to the world, as he accepts the apple (symbolizing man's fall from grace) from the infant St. John the Baptist, whose mother, St. Elizabeth, wrings her hands in anticipation of Christ's sacrifice on the cross. Steeped in shadow, Joseph represents the in-visible God on earth. As creator of the universe, he draws with a compass.

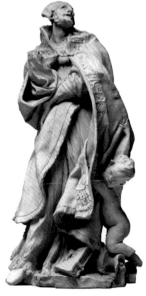

38 During the 1660s, the French sculptor Pierre Puget worked in Genoa, where he was hired by the patrician Sauli family to provide decorations for the church of Santa Maria Assunta di Carignano. Among these works was an over-life-size marble statue of their late son, **Alessandro Sauli,** a locally venerated bishop who was a candidate for

sainthood. This terracotta was the final study for the marble. Sauli's bearded, ascetic face, tilted toward heaven, displays the physical vigor and emotional intensity that were hallmarks of Puget's baroque style. The rapid modeling and complex, contrasting diagonals create a sense of passion and urgency.

39 After its invention in 1656, the superior accuracy of the pendulum **Clock** caused it to be widely used by those who could afford it. The mechanism for this example was the work of the Parisian Baltazar Martinot. The case was made by André-Charles Boulle, the most celebrated French cabinetmaker during the reign of Louis XIV (1643–1715). Boulle's name is synonymous with the marquetry technique shown here: inlays of brass, pewter, and tortoiseshell, with other surfaces covered with ebony. Further embellishing the clock are gilt-bronze mounts, such as the finial, shaped like an antique lamp, and the sphinxes at each side, both associated with ancient times. The gilt-bronze figural group beneath the clock face probably represents "Time abducting Beauty."

39 *Clock,* about 1695
André-Charles Boulle

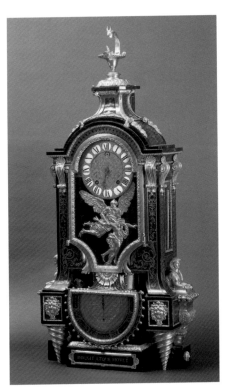

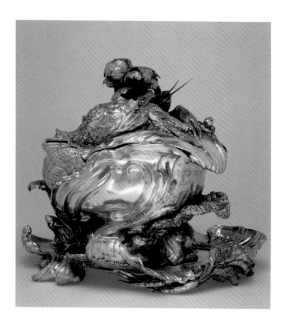

40 This silver **Tureen** from the 1730s was
designed for an English nobleman by the
originator of the French Rococo, Juste-Aurèle
Meissonnier, and epitomizes the inventiveness
of that cosmopolitan style. Its swirling asym-
metrical design combines remarkably realistic
detail with imaginative, abstract forms based on
marine motifs. Perched atop the shell-shaped
lid is a crayfish that Meissonnier probably
cast from nature. The animals and vegetables
decorating this piece suggest the ingredients
of the stew it might contain. Today only three
pieces of this elaborate service are known.

41 Paris in the 18th century was the locale of
the manufacture of much of the best furniture
ever created, but many of the cabinetmakers
working there—like Jean-Pierre Latz—were
of German birth. This **Tall Clock** reflects the
rococo style favored by Latz's aristocratic
European clientele, especially the royal German
and imperial Russian courts. The case features
boulle marquetry: tortoiseshell inlaid with
brass embellished with large-scale gilt-bronze
mounts. Cupids and dragons frolic amid elabo-
rate rococo scrollwork. To control cost and
design, Latz probably cast the mounts in his
own workshop, a violation of strict guild regu-
lations that required separate craftsmen for
each material or mode of fabrication.

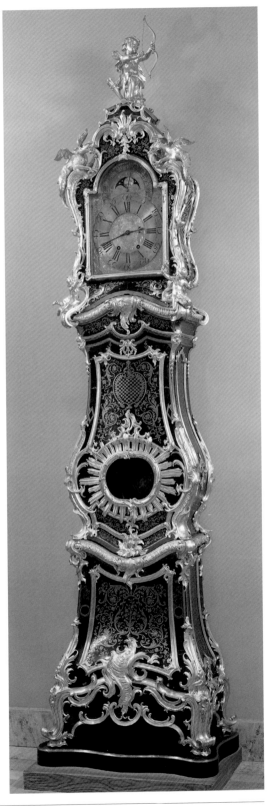

42 Although largely self-taught, John Singleton Copley was the first American artist to produce works equal in quality to those of European court painters. His paintings provide accurate depictions of figures like the silversmith **Nathaniel Hurd,** a patriot and friend of Paul Revere, who played an important role in the American Revolution. Because Hurd made his living as a craftsman, Copley accentuated his hands and showed him dressed somewhat informally. However, Hurd was also educated, so Copley showed him with books such as Guillim's *A Display of Heraldry,* which Hurd used as a reference when he engraved silver vessels. The museum owns a teapot by Hurd that is decorated with a coat-of-arms copied from this very source.

42 *Nathaniel Hurd,* about 1765 John Singleton Copley

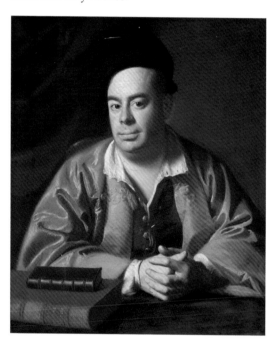

43 The influential neoclassical artist Antonio
Canova began this sculpture in 1808 as an alle-
gorical portrait of Mme Lucien Bonaparte, a
sister-in-law of Napoleon, who lived in Rome
where Canova had a studio. The commission
was canceled, and Canova transformed the
sculpture into a depiction of **Terpsichore** as
the muse of lyric poetry, not as the muse of
dance, her usual guise. Canova incorporated
the ideals of ancient classical art into his own
distinctive style, as seen, for example, in the
figure's pose and her complex costume.
Canova paid particular attention to the careful
rendering of details and textures in his sculp-
tures. This *Terpsichore* of 1816 is the second of
two marble versions.

43 *Terpsichore,*
1816
Antonio Canova

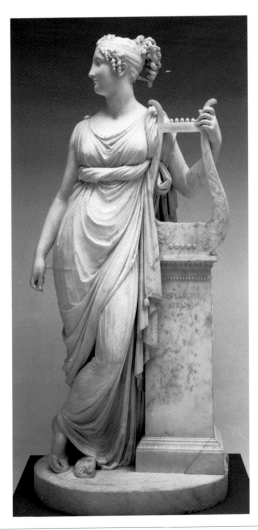

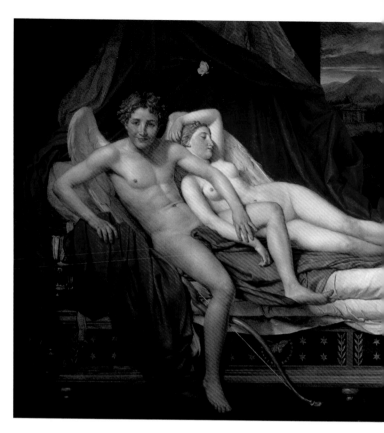

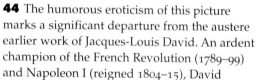

44 *Cupid and Psyche*, 1817 Jacques-Louis David

45 *Don Juan Antonio Cuervo*, 1819 Francisco de Goya

44 The humorous eroticism of this picture marks a significant departure from the austere earlier work of Jacques-Louis David. An ardent champion of the French Revolution (1789–99) and Napoleon I (reigned 1804–15), David

painted **Cupid and Psyche** during his political exile in Brussels following Napoleon's defeat at Waterloo. While in Belgium, the painter reverted to favoring sensuality over the heroism of his earlier official art. Here, David depicted Cupid trying to slip away from his lover's bed. Smitten with Psyche, Cupid had whisked the mortal to his palace, visiting her only in the darkness of night, warning her that she must never see his face. Thus, he always stole

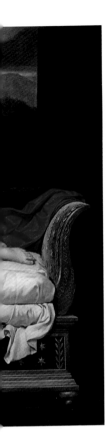

from their bed before sunrise. In this painting, however, his wing is trapped beneath her body and day is at hand.

45 Francisco de Goya painted this portrait in 1819, shortly before poor health forced the artist to withdraw to the *Quinto del Sordo* (the house of the deaf man) near Madrid. Goya depicted his successor at the Royal Academy, architect **Juan Antonio Cuervo,** outfitted in the academy's official costume. Spread out before the architect is a plan for the reconstruction of the Church of Santiago, on which he had worked in 1811. In his hand, Cuervo holds a draftsman's compass, an attribute of his profession. By portraying him with this implement, and looking over his plans, Goya continued the long-standing tradition of the biographical portrait. His broad, quick brushwork honestly and incisively captured the sitter, projecting a demeanor of robust, coarse vitality and self-assurance. Goya's rapidly executed technique links late 18th-century painting to art of the modern age.

46 On the night of October 16, 1834, flames from an unattended furnace destroyed the British Houses of Parliament. Among the throngs that gathered to watch was the painter J. M. W. Turner. Following his usual working practice, Turner made sketches and studies of the fire while it was burning and then reworked

46 *The Burning of the Houses of Lords and Commons,* 1835
Joseph Mallord William Turner

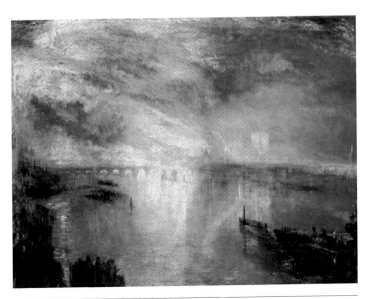

them in his studio to render **The Burning of the Houses of Lords and Commons.** Turner transformed the flames into a surging maelstrom of vigorously applied, radiant color, emphasizing the helplessness of mankind in the face of nature's awesome power, a subject dear to Romantic art.

47 William Sidney Mount was one of the first American painters to record scenes of everyday life. Using his Long Island birthplace as a setting, his narratives largely occurred in the decades leading up to the Civil War (1861–65). The barn depicted in **The Power of Music** was near Mount's Stonybrook home. This powerful

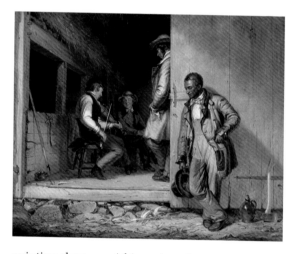

47 *The Power of Music*, 1847 William Sidney Mount

painting shows an African-American man pausing in his workday to enjoy the tunes of the fiddle. Although a love of music connects the figures and briefly heals the social divisions of race, the middle-aged man remains hidden, still outside the barn door. A reflection of the era, the unresolved racial issues so eloquently portrayed in Mount's painting still resonate today.

48 Frederic Edwin Church was considered the most famous painter in America when he created this scene of **Twilight in the Wilderness**. The view is a composite of sketches made in Maine and New York. From the meticulously rendered foreground, where an eagle perches on a gnarled, dead tree, to the swirling clouds reflected in the water, Church clearly lavished

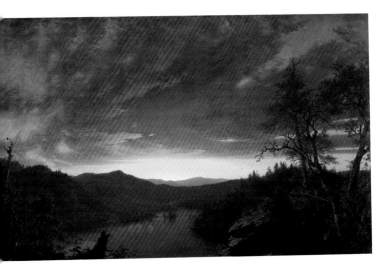

48 *Twilight in the Wilderness*, 1860 Frederic Edwin Church

attention on this work. On one hand, the painting reveals God's glorious gift of un-spoiled natural terrain, but Church made the picture one year before the onset of the Civil War (1861–65). Thus it may be seen to depict an Edenic America at that last moment of calm before nightfall in which the flaming, crimson sky signals the bloody dawn of a new era.

49 Herter Brothers produced what is arguably the finest furniture created in America during the 1860s and 1870s, when this carved and gilded **Fire Screen** was made. Founded in New York by German-born Gustave Herter—who

49 *Fire Screen*, about 1878–80 Herter Brothers

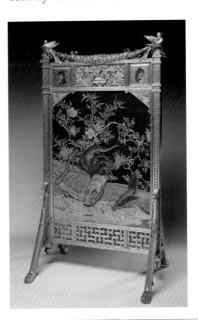

was later joined by his half brother Christian—the firm excelled at synthesizing disparate decorative elements into a unified whole. The screen was designed to accommodate a painted and gilded embossed paper panel of exotic birds and flowers, which was almost certainly made in Japan. Chinese-style fretwork adorns the bottom of the screen, while a heavy garland, reminiscent of ancient Rome, crowns the top. Although the firm is known to have made a quantity of gilded furniture, this screen is one of only a few examples to survive in good condition.

50 Dora Wheeler was William Merritt Chase's first New York pupil after he returned to this country from Europe. In this painting, which she gave to the museum in honor of her friend Jeptha Wade, one of the museum's founders, she is poised to receive guests at one of the teas she served every Thursday in her garret studio in New York. The prominence of the dramatic, gold silk tapestry behind her is no accident, for Wheeler spent much of her career designing embroidered textiles. At the time of Chase's portrait, Wheeler's mother, Candace, had just

50 *Dora Wheeler,*
1882–83
William Merritt
Chase

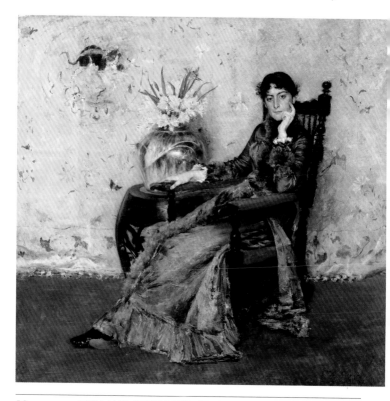

broken off her partnership with Louis Comfort Tiffany (1848–1933) to establish a new textile firm with her daughter—one of the first businesses in the United States to be staffed entirely by women.

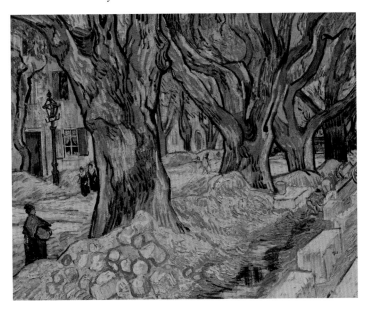

51 *The Large Plane Trees,* 1889 Vincent van Gogh

51 While voluntarily committed to an asylum in St.-Rémy, France, in the spring of 1889, the Dutch artist Vincent van Gogh was allowed to take brief chaperoned painting trips around the French town. On December 7 he wrote to his brother Theo in Paris: "The last study I have done is a view of the village, where they were working—under enormous plane trees—repairing the pavement." In his rush to capture the yellowing leaves of the **Large Plane Trees,** but lacking a proper canvas, he painted on a small piece of cheap linen with a diamond pattern that still remains faintly visible in some areas. The spontaneous, impulsive brushwork, coupled with heightened colors and exaggerated forms, infuses the scene with intense excitement.

52 Degas adored the ballet, preferring his pass to the Opéra Garnier in Paris to membership in the Legion of Honor. He saw in dance "the last vestiges of the Greeks," and this long, narrow composition from the last decade of the 19th

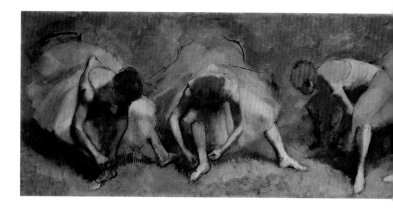

52 *Frieze of Dancers*, 1895 Edgar Degas

century alludes to the sculptural friezes of classical Greek architecture. **Frieze of Dancers** depicts four views of a single dancer adjusting her slipper. The splashes of green paint evoke shadows and highlight the ballerina's red hair. In contrast to a monochrome sculptural frieze, the vibrant, diverse colors create a sense of hypnotic movement.

53 Decorative arts flourished in Paris around the turn of the century. Reinforcing this trend were the commissions of the wealthy French banker and collector Baron Joseph Vitta, who called upon some of the era's finest artists to create interior decorations and a series of

53 *Hand Mirror*, 1900 Félix Bracquemond, Auguste Rodin, Alexandre Riquet

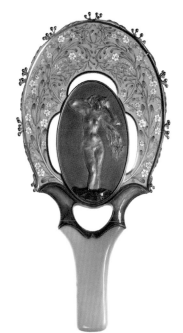

elegant objects, the latter probably intended as gifts for his mother. Artist and printmaker Félix Bracquemond designed this **Hand Mirror,** centered with a gold figure in relief of Venus Astarte, the Phoenician goddess of love. The celebrated sculptor Auguste Rodin made the model for the relief, which the Parisian firm of Falize cast in gold. Master enamelist Alexandre Riquet translated Bracquemond's delicate floral design into translucent enamel.

54 In 1901, Paul Gauguin moved from France to the remote Marquesas Islands in the South Pacific, where he painted **The Call** in 1902, a year before

his death. From a series that explores the mysteries of life and death, this painting portrays three women in varying degrees of nakedness. The fully clothed woman glances toward the viewer but shields herself with one hand. The half-dressed woman beckons beyond the picture frame to someone who seems to draw the attention of the squatting woman in the rear. However, who is being called and why remains puzzling. Gauguin underscored this sense of mystery with his use of vibrant, decorative colors.

54 *The Call,* 1902
Paul Gauguin

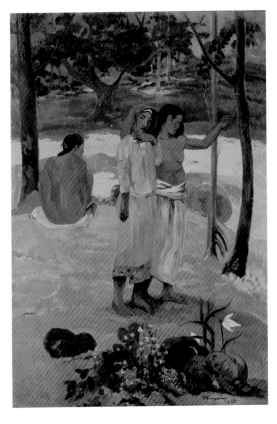

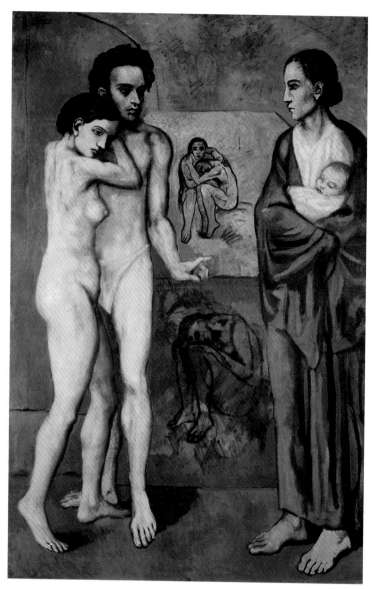

55 *La Vie*, 1903
Pablo Picasso

55 During his long, remarkable career, Pablo Picasso's prodigious body of work had a profound impact on 20th-century art. **La Vie,** or *Life,* is among the largest and most complex paintings of Picasso's early Blue Period (1901–04). It was painted in Barcelona, where the artist spent some of his early years before moving permanently to France. In austere blue tones, set in an artist's studio, the picture depicts two groups of slender, melancholy figures separated by unfinished canvases propped against the wall. Picasso originally made the male figure a self-portrait, but he later changed the face

to resemble that of Carlos Casagemas, a friend who had committed suicide after being rejected by a lover. Extensive study has yet to define the meaning of this complex meditation on love and life.

56 In 1907, the Galerie Hébrard in Paris exhibited the highly original furniture and objects of the Italian designer Carlo Bugatti. Made as an ensemble, this group consisting of a **Table, Salver,** and **Tea Service on Tray** was probably purchased from the exhibition by Anna Blake, a wealthy South African widow then living in Paris. The animal and insect forms were said to have reminded her of Africa. Motifs derived from flora and fauna had long intrigued the designer, as had oval forms, and both were

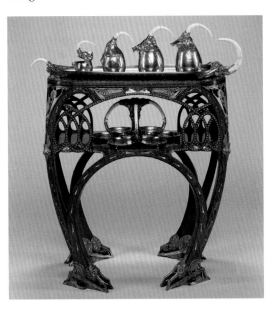

56 *Table, Salver,* and *Tea Servive on Tray,* about 1907 Carlo Bugatti, A. A. Hébrard Firm

used here in a notably stylized form. This beautifully crafted ensemble reflects Bugatti's technical refinement and is a fine example of his late work influenced by French taste.

57 Although public boxing fights were illegal, Sharkey's Saloon held them anyway under the pretext that it was a private club. The popular Manhattan saloon was directly across the street from the studio of the painter George Bellows and provided the setting for this early canvas of 1909, **Stag at Sharkey's.** Bellows painted the boxing match with the instinctiveness of the

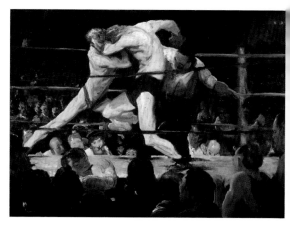

skilled athlete that he was (having turned down a professional baseball contract to become an artist). Using vigorous, rapid brush-work to blur details, Bellows captured the force and energy of the scene, and his low vantage point places the viewer almost at ringside. Bellows was associated with the Ash Can School, whose name derived from the group's gritty scenes of everyday urban life.

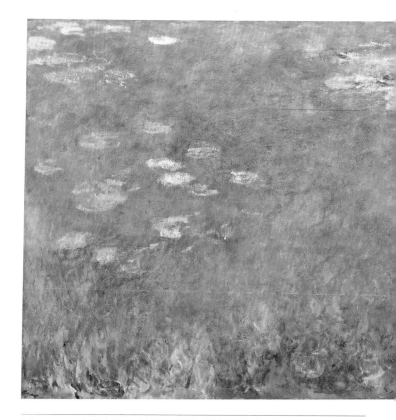

58 In 1914 Claude Monet wrote, "I am hard at work…I have undertaken a large work that thrills me," referring to his *Grande Décoration*, a series of monumental paintings of the beloved lily pond in the gardens of his home at Giverny. These paintings—of which **Water Lilies** is one—occupied Monet until his death. Monet intended to group this painting with two others (today in Kansas City and St. Louis). Collectively known as *L'Agapanthe,* these three canvases depicted the lily pond and agapanthus flowers growing along its banks. Later Monet painted over the agapanthus to focus on the water's shimmering surface, the swaying water grasses, and reflections of the moving clouds.

58 *Water Lilies,*
about 1915–26
Claude Monet

20th Century and Beyond

This collection contains some 375 paintings and sculptures that reveal the diversity of subject matter, styles, techniques, and materials of the period. The museum has extensive holdings of works by major American, British, and German artists.

59 Just before the First World War (1914–18) two young artists, based in Paris, invented a radically new kind of painting that even today remains a powerful influence. Pablo Picasso and Georges Bracque dispensed almost completely with visual resemblance to the world, substituting an intellectual method of abstraction that challenged every convention and created a revolutionary conception of space, even a redefinition of reality in art. The objects in **Bottle, Glass, and Fork** have transcended literal depiction to become signs or symbols in Picasso's own poetic language.

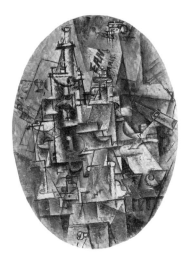

59 *Bottle, Glass, and Fork*, 1911–12
Pablo Picasso

60 Charles Sheeler based this view of lower Manhattan from a building on Broadway and Wall Street on an image from *Manahatta* (1920), a film on which the artist collaborated with the photographer Paul Strand. A distinguished photographer of architecture in his own right, Sheeler often found his subjects in the geometric patterns of the modern city. In **Church Street El,** he simplified and flattened shapes, eliminating detail to focus on the interplay of colors and patterns of light. The energetic, upward diagonal of the brown train tracks on the right suggests the train's surging speed. Sheeler's pristine, unpopulated scenes of American life made the artist a key figure in Precisionism, a trend between World War I and World War II fusing European Cubism with American realism.

61 Surrealist artists believed that reality can be understood only through knowledge of the unconscious. The Spanish Surrealist Salvador Dalí produced many paintings inspired by the

60 *Church Street El*, 1920
Charles Sheeler

theories of Sigmund Freud and the science of psychoanalysis. One of Dalí's most powerful Surrealist paintings, **The Dream** gives visual form to the strange, disturbing world of dreams and hallucinations. The central figure—having sealed, bulging eyelids and ants clustered over its face—may suggest the sensory confusion and frustrations of a dream. The golden key or scepter held by the man sitting on a pedestal probably symbolizes access to the unconscious. Dalí insisted that this work represent him at the First International Surrealist Exhibition, organized in London in 1936.

61 *The Dream*, 1931
Salvador Dalí

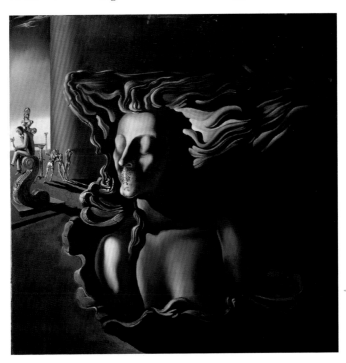

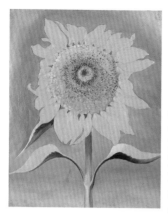

62 "It is only by selection, by elimination, by emphasis that we get at the real meaning of things," stated Georgia O'Keeffe, pioneer of American modernism. **Sunflower, New Mexico I** is from a series of sunflower images that O'Keeffe made at her summer home at Ghost Ranch in New Mexico in 1935. The artist streamlined the flower, simplifying and enlarging details to emphasize its essential beauty. The monumental yellow flower boldly stands out against the bright Southwestern sky—almost like an icon.

62 *Sunflower, New Mexico I, 1935* Georgia O'Keeffe

63 Despite the onset of World War II (1939–45), Henri Matisse used glowing color and decorative shapes to infuse this image of his apartment

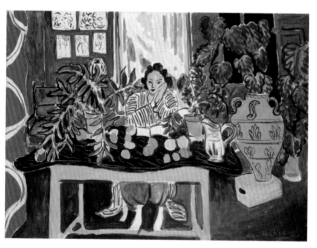

63 *Interior with an Etruscan Vase, 1940* Henri Matisse

in Nice in the south of France with a feeling of quiet, meditative relaxation. Dedicated to Fauvist principles, Matisse continued to liberate color from nature by using explosive hues and lively, imaginative design. In **Interior with an Etruscan Vase,** a woman wearing a brightly colored Moroccan costume sits behind a table, surrounded by luxurious plants and works of art. The neutral black table anchors the brilliant colors of the orange vase and red curtain. As Matisse once declared, "I have always... wished my works to have the lightness and joyousness of a springtime which never lets anyone suspect the labors it has cost."

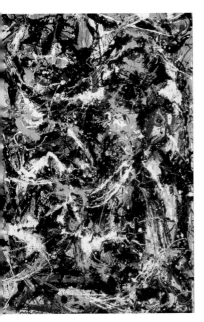

64 Jackson Pollock was the most inventive of a group of American artists living in New York after World War II. His large-scale, improvisational, and expressive abstractions changed the face of contemporary art. Known as Abstract Expressionists, Pollock and his colleagues were inspired by the Surrealist technique of automatism to delve into the unconscious. **Number 5, 1950** reveals Pollock's famous "drip" technique in which he started spontaneously exploring the random, chance effects of falling paint. He moved around the canvas placed on the studio floor, dripping, pouring, or flinging paint with sticks or blunt brushes. He then made changes in the composition until a sense of harmony and order replaced chaos. The resulting "all-over" web of rhythmic, interlacing lines projects great energy and passion.

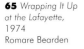

64 *Number 5, 1950*, 1950
Jackson Pollock

65 Romare Bearden inventively combined the European Cubist tradition of collage with the spirit and reality of African-American culture. From his 1974 *Of the Blues* series, the exuberant collage **Wrapping It Up at the Lafayette** reflects

65 *Wrapping It Up at the Lafayette*, 1974
Romare Bearden

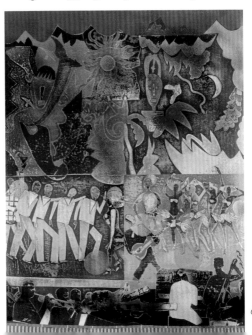

61

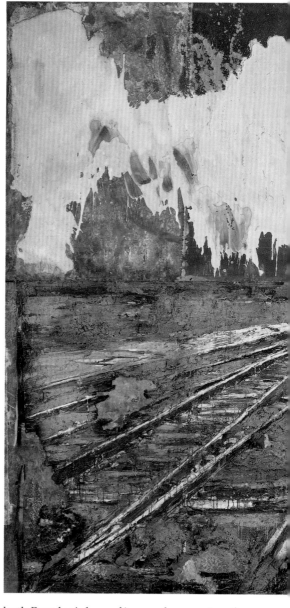

both Bearden's love of jazz and memories of
his youth. It depicts the Lafayette Theater in
Harlem, famous for its musical revues and
plays during the 1920s and 1930s. In the band
pit at the bottom, musicians accompany the
lively quartet and chorus girls onstage. Behind
them, an exotic jungle backdrop is topped by a
scalloped red curtain. Just as jazz relies on im-
provisation, Bearden's rhythmic arrangement
of diverse bits of fabric, scraps of paper, and
pictures from magazines looks impromptu and

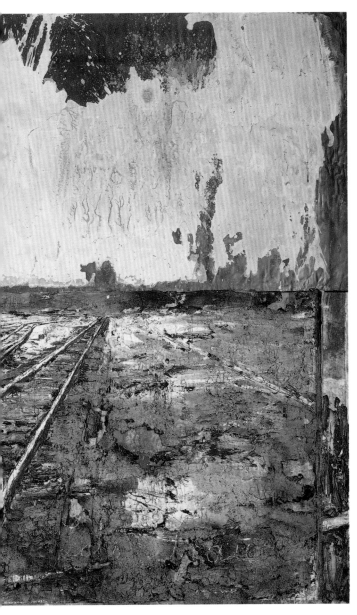

unrehearsed, yet simultaneously structured and
disciplined.

66 In **Lot's Wife,** Anselm Kiefer reinforced his
reputation as an intensely physical and meta-
physical artist. Weighing some 1,200 pounds,
the lower section of this two-part, lead-paneled
work depicts empty railroad tracks in a charred,
barren landscape. Kiefer burned the canvas in a
number of places and covered it with a thin
layer of ash. The painting's title and the artist's

use of salt to create an eerie, iridescent sky refer to the biblical story of Lot's wife—who turned into a pillar of salt after disobeying God's warning not to look back during the destruction of the cities of Sodom and Gomorrah (Genesis 19:1–28). A German born in the last year of WWII, Kiefer may suggest with the railroad tracks the deportation of Jews to death camps during the Holocaust, while the scorched earth may allude to human suffering and environmental blight.

67 For over forty years Frank Stella has remained at the forefront of contemporary art by continually challenging traditional categories in art. **Çatal Hüyük,** an imposing 1,700-pound vortex of cast and welded aluminum, demonstrates this tendency. Alive with gesture and expression, it hangs on the wall like a painting but projects into space like a sculpture. *Çatal Hüyük* is named for an archaeological site in Turkey where ancient cave paintings were discovered. The poured and cut elements assembled here may allude to the primal animal scenes found there, as well as the process of excavation. However, by designing shapes with the aid of a computer and creating his work in a foundry, Stella abstracts such timeless themes and introduces associations with modern technology and industry.

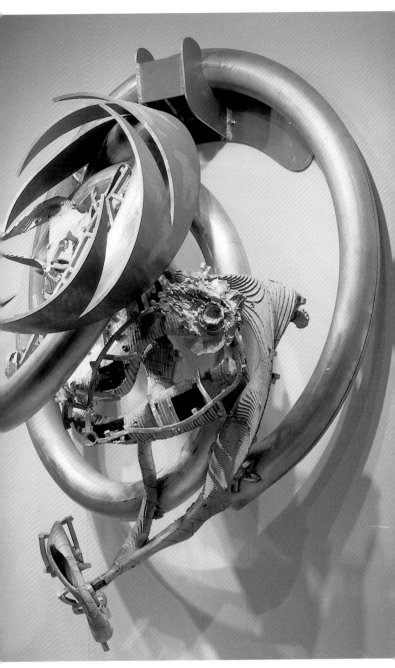

67 Çatal Hüyük,
(level VI B) Shrine
VI B.1, 2001
Frank Stella

African Art The African collection includes about 300 works—mostly wooden sculptures but also ivory, gold, ceramic, bronze, and stone objects —from the major culture areas of western and central Africa. With the exception of a few archaeological objects from the Nok and Jenne cultures, which date as early as 650 BC, most works were created during the late 19th or early 20th centuries. The collection is rich in masks that transformed their wearers into powerful embodiments of unseen, otherworldly spirits, reflecting the crucial importance of masquerade in Africa, and several bronzes from Benin, made to honor the royalty of one of West Africa's greatest kingdoms.

68 Among the Bamana people of Mali, **Antelope Headdresses** relate to the *ciwara* initiation society, whose purpose is to instruct its members in agricultural practices. Every young Bamana man aspires to the honorary title of "champion farmer." The recipient of this title may wear an antelope headdress in dance performances. Often, the ciwara dancers perform in pairs, male and female. This example —which was originally attached to a wicker cap—is carved in the horizontal style typical of the Beledougou area. Made from two pieces of wood, it combines the horns of an antelope

68 *Antelope Headdress, about 1920s Mali*

with the tail of a chameleon and the body of an aardvark. These and other animals embody the virtues of the champion farmer.

69 Approximately 400 years ago, this idealized brass portrait of a deceased Benin *oba,* or divine king, was commissioned by a successor to be the centerpiece of a raised earthen altar in the palace. This ancestral altar then became the focus of rituals essential to the well-being of the

69 Head of a King, 1600s Nigeria

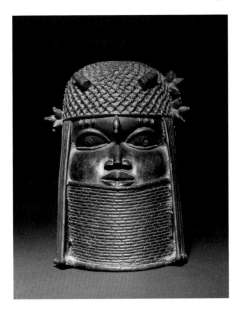

entire Benin kingdom. Only specialized royal artisans could cast the commemorative **Head of a King,** since only kings could commission works of brass, a sacred material. This head supports an elaborately carved ivory tusk—dating to the 1800s—that symbolizes the spiritual powers emanating from the king's sacred head. The sculpture reflects the remarkable flowering of the arts from 1400 to 1900 of the powerful Benin nation, now southern Nigeria.

70 The Bwa and the so-called Gurunsi—a collective name for a number of farming groups, including the Nuna, Nunuma, Winiama, and Lela—share the same types of wooden masks decorated with colorful geometric patterns in white, red, and black. Considering this **Buffalo Mask's** large size and its relatively simple designs, it is most likely of Bwa origin. The masks

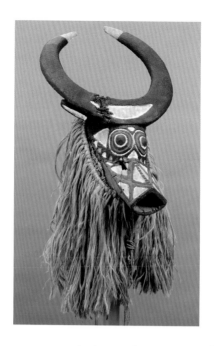

70 *Buffalo Mask, about 1940s Burkina Faso*

71 *Male Figure, before 1930 Democratic Republic of the Congo*

were worn during performances at all important events in village life, such as initiations of boys and girls, funerals, and annual renewal ceremonies. Many of these masks depict animals or refer to specific characters from family and clan myths. The horns and muzzle of this example identify it as representing a buffalo.

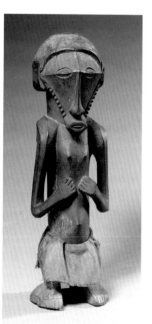

71 The Basikasingo, and other small hunter groups living near Lake Tanganyika in eastern Congo, are referred to as the "pre-Bembe." Figures with a distinctive style—like this **Male Figure**—have often been wrongly attributed to the Bembe people, who strongly influenced the culture of the so-called pre-Bembe hunters. Either male or female, these objects honor the founders of small political groups. As part of an ensemble of stylistically related figures, they are housed in a shrine, playing a role in the ancestor cult. In order to assure the benevolent intervention of the ancestors in times of crisis, they receive offerings and prayers from their custodians.

72 *Mother and Child*, late 1800s–early 1900s Democratic Republic of the Congo

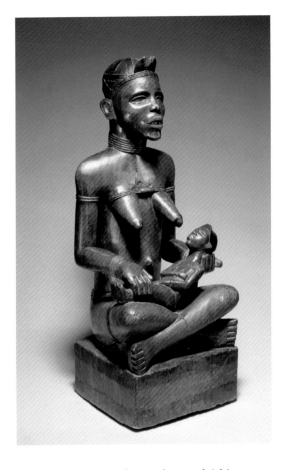

72 Kongo society of coastal central Africa—which is composed of many ethnic groups ruled by village elders and chiefs—is matrilineal. Thus, the chief's legitimacy derives from his female ancestors. The large size and lightweight wood of this moving **Mother and Child** sculpture indicate a funerary function and its placement either atop the grave of a chief or within his ancestral shrine. Wearing a prestigious patterned cap and armbands, with a rapt expression on her gaunt face, this woman clearly played a critical, powerful role within her clan, perhaps as the original mother of the chief's ancestral line.

Islamic Art

The Islamic art collection comprises works made primarily in Iran, Egypt, and Turkey since the 9th century. Most of the 150 or so items are on exhibit, with the exception of works on paper. Particularly notable are metalwork, ceramics, glass, and miniature paintings.

73 Known internationally as the Wade Cup, this **Silver Inlaid Brass Bowl** is a worthy tribute to J. H. Wade, who co-founded the museum, donating funds for purchasing art as well as individual works. Real and imaginary animals decorate interlacing bands around its body, interspersed with signs of the zodiac. Surrounding the rim, lively humans and animals assume positions of hunting and dancing that ingeniously form the letters of a legible Arabic inscription. This animated script, read from right to left, extends customary good wishes: "Glory

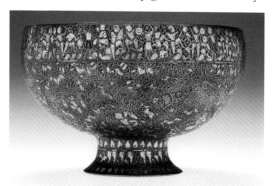

73 Silver Inlaid Brass Bowl, 1200s Iran

and success, and government, and bliss, and soundness, and peace of mind, and mercy, and well-being, and good health, and duration, and increase, and satisfaction, and care, and continuance to its owner."

74 The brilliantly colored, gilded, enameled glass produced in Egypt and Syria during the powerful Mamluk dynasty (1250–1517) around 1350 was coveted not only in Islamic countries but in Europe as well. This wide-brimmed **Ceremonial Spittoon or Basin** is unique in Mamluk glassware. Painted on transparent glass, then heated one color at a time, the enameled shades of blue, red, and white are unusually thick and intense. Contrasts between curved and angular designs compose the elaborate, harmonious decoration. The production of

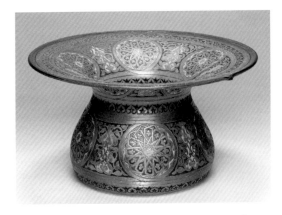

74 *Ceremonial Spittoon or Basin,* about 1350 Syria or Egypt

Mamluk glass stopped inexplicably around 1400, but the technique, a closely guarded secret, had great impact later on the glass industry in Venice.

75 In 1601, Polish King Sigismund III Vasa sent an emissary to Kashan, Iran—famous for its silk industry—to oversee the weaving of a group of carpets he had commissioned there. These luxurious carpets were woven in silk with gold- and silver-metal threads. Because some bore Polish coats of arms, this type of metal-threaded silk carpet is known as a **Polish Carpet** and was among the most prized type produced in Iran during the 16th and 17th centuries. In this small, elegant example, two central leaf medallions are framed by a masterfully designed, uninterrupted flowering vine pattern. The splendid coral and green coloring, so characteristic of Polish carpets, still remains intense.

75 *Polish Carpet,* about 1600 Iran

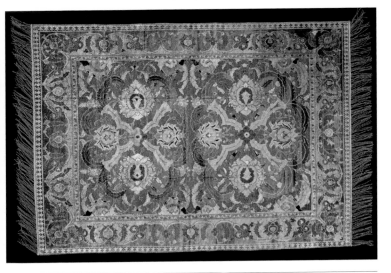

China

From prehistory to the modern era, the Chinese art collection spans more than 5,000 years. It encompasses a variety of art forms, including sculpture, bronzes, jades, ceramics, lacquer, bamboo carvings, paintings, and calligraphy. Emphasis has been placed on paintings and ceramics, the most outstanding sections of the collection.

76 *Square Wine Bucket*, about 1100–1050 BC China

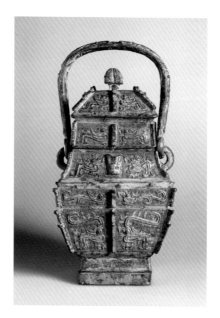

76 Dedicated to "Lady Qi," this **Square Wine Bucket,** or *fangyou,* was central to ritual ceremonies devoted to deceased ancestors during the Shang dynasty (about 1600–1023 BC). These rituals were practiced only by the elite, such as Lady Qi, who was probably buried with this prized vessel in the Shang capital of Anyang. The city's large foundries produced bronze vessels of an aesthetic and technical quality unrivaled by any other Bronze Age culture. This detailed, finely cast wine bucket is unusually shaped, having four beautifully balanced concave and convex sides, as opposed to the era's more typically rounded form. Centuries of exposure to earth and air have caused the once shiny object to develop a colorful, jade-like surface, or patina.

77 Two extraordinarily tall cranes stand above a pair of intertwined snakes to form a **Drum Stand**. This animal combination is unique in Chinese art. A light drum would have been suspended between the birds' long necks. The drum was probably part of the large orchestras that were popular in southern China during the late Bronze Age, some 2,000 years ago. Coats of

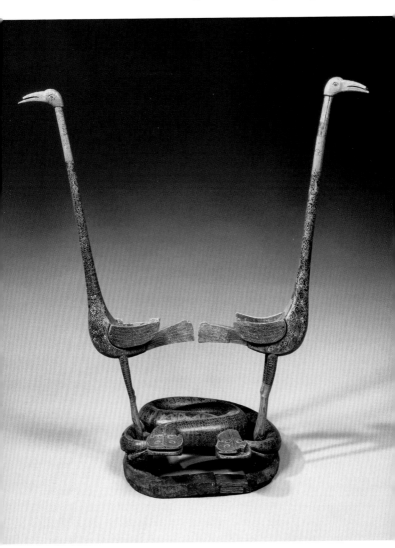

77 *Drum Stand,*
300–221 BC
China

brilliantly colored lacquer protectively seal and embellish the wooden sculpture. As was common during this period, the designs—painted in red on a black ground—form an intricate, lively blend of natural and geometric patterns.

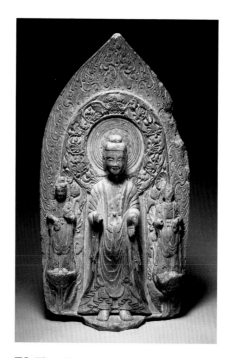

78 This Chinese sculpture was one of the earliest gifts to the Cleveland Museum of Art. Called a **Stele,** or freestanding stone monument, it was commissioned by Prince Gaoping in memory of his deceased consort, and carved by one of the finest craftsmen in the capital city of Ye. The stele depicts a large image of the Indian prince Shakyamuni, or the Historical Buddha, who founded Buddhism in the 6th century BC. Flanked by smaller attendants, he conveys a calm, smiling confidence that was an assertion of religious faith during a period marked by great political instability.

79 These fierce **Tomb Guardians** (*zhenmushou*) are covered in the three-color glaze of *sancai* ceramics, with amber, green, and white as the dominant hues. The additional color of blue indicates the princely status of the individual who was to receive protection from this pair. Like other tomb guardians, these are both animal-shaped but are not identical. One sports an animal head resembling a snarling wolf, and the other a human face with huge, protruding leaf-like ears. These sculptures were used in a funerary context, most likely within a royal tomb, where they protected the deceased from evil spirits.

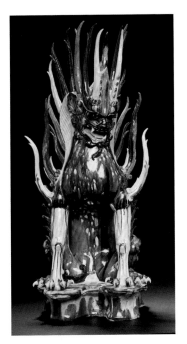
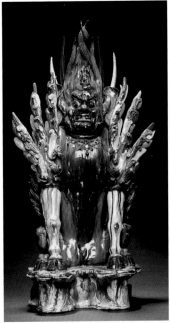

79 *Tomb Guardians*, late 600s or early 700s
China

80 This superbly preserved silk handscroll is a landscape—or *shanshui* (mountain-water) in Chinese—from the early Jin dynasty (about 1127–50). It sweeps at a serene and leisurely pace. Unrolled right to left, **Streams and Mountains without End** is meant to be viewed sequentially, section by section, as a journey through time and space. Thus, the artist included walking paths and boats to encourage forward movement, as well as living quarters and pavilions that invite rest and repose. Rendered with impeccable detail, the rich variety of scenes entices not only the tiny figures within the landscape but also those viewing the scroll.

80 *Streams and Mountains without End* (detail), about 1127–1150
China

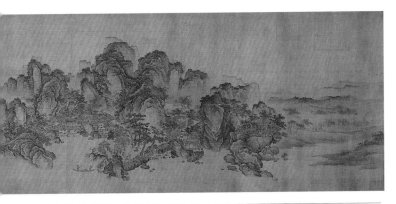

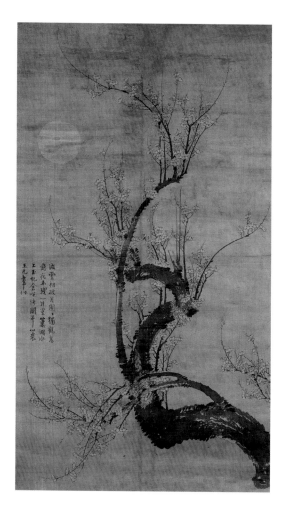

81 During the brief Yuan dynasty (1279–1368), many scholars turned to creative pursuits, such as art, rather than serving under the foreign Mongol emperors. Among these scholar-artists was Wang Mian, who was celebrated for his depictions of plum blossoms. The plum tree, often the first to bloom in the spring, is a harbinger of a new year and an emblem of the soul's virtue. In this delicate silk hanging scroll titled **A Prunus in the Moonlight,** gnarled old branches of the plum tree sprout delicate new blossoms. Moonlight accentuates the icy purity of these blooms, infusing an inner luminosity throughout the entire image. The plum tree may also symbolize the artist himself as an aging man who still could bloom like a mass of flowers.

82 Around 1525, the Ming Emperor Jiajing (reigned 1522–66) presented a gift of embroidered silk to his minor court official Wen Zhengming, presumably to commend a job well done. In return, the renowned calligrapher and painter created this monumental poem of gratitude in the most revered of Chinese art forms: **Calligraphy in Running Style.** To compose the characters linked by brushstrokes on the more than 11-foot-long scroll, Wen Zhengming would have had to place the paper on the ground and wield a very large brush. The masterful control over the flow and flux of the characters reflects years of training as well as moments of inspired creation.

82 *Calligraphy in Running Style* (detail), about 1525 Wen Zhengming

83 One of the most powerful imperial images in all of Chinese art, this painting is actually a private document, for the emperor's eyes only. Begun in 1736, the silk handscroll portrays, at almost life-size, the Emperor Qianlong (reigned 1736–96)—then in his early twenties and about to ascend the throne—and his empress and concubines. The artist of these realistic **Inauguration Portraits** was Giuseppe Castiglione (also

84 *Fish and Rocks*, 1644–1705
Zhu Da

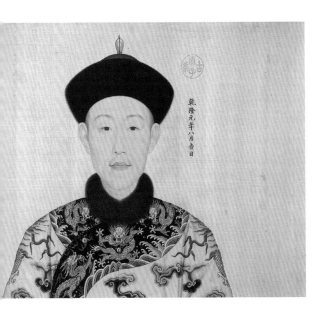

known as Lang Shining), a Jesuit born in Milan who taught European painting techniques at three early Qing dynasty courts. Bowing to imperial demand, Castiglione suppressed the shadows so customary in Western portraiture. The resulting images—with their flat, even illumination over impeccably rendered faces and richly embroidered robes—display the blending of East and West in a successful synthesis of styles.

84 A descendant of a branch of the Ming imperial family, Zhu Da lost princely status after the Manchu conquest and subsequent establishment of the Qing dynasty in 1644. He adopted a new name, retreated to Buddhist monasteries where he found solace in the arts, and at times feigned insanity to avoid detection. In this short handscroll, **Fish and Rocks,** Zhu Da juxtaposed strange, sparse images in a simple, sweeping style using few brushstrokes. The fish swim in opposite directions, and the rocks float in a void. He also included three cryptic poems that have similarly alienated themes, referring perhaps to the Ming marginality in Manchurian society.

Japan and Korea

The museum possesses important examples in metalwork, lacquer, sculpture, painting, and ceramics from both Japan and Korea. The collections were initially formed at the time of the museum's inception, developed significantly following World War II and the Korean War, and continue to grow, especially in the traditional arts of Korea.

85 The earliest Neolithic hunter-gatherers in Japan were known as the Jōmon. They lived in small settlements along coastlines and inland plains where they produced a variety of creative, often extravagant utilitarian pottery that varied according to region. Ceramics like this **Flame-Style Storage Vessel** were produced only in the Niigata area on the Japanese seacoast northeast of Tokyo. Used for cooking and storage purposes, they were handmade, perhaps by individual families, from stacked coils of clay that were then embellished with a variety of decorative, lively patterns, including this "flame-style" design on the rim. Some 4,500 years old, this Niigata vessel is particularly sculptural and appealing today.

86 Buddhism was still in its infancy in Japan when this bronze devotional image was cast in the late 7th century. Still retaining traces of

85 *Flame-Style Storage Vessel, about 2500 BC Japan*

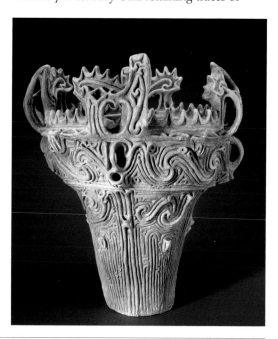

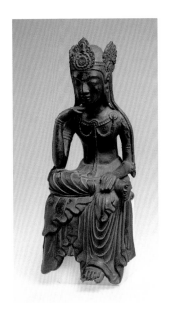

gilding, the serene, seated figure portrays Maitreya (Miroku in Japanese), the **Buddha of the Future,** who would appear at the end of the world to offer salvation. This compassionate deity was extremely popular during this period, especially among the aristocracy who were the new religion's strongest supporters. Japanese Buddhist communities built temples that initially echoed mainland Korean and Chinese styles, as did the icons themselves. However, these sculptures gradually took on more decidedly Japanese characteristics, as shown here, with Maitreya's stocky torso and broad face and features.

86 *Buddha of the Future,* late 600s
Japan

87 The arrival of Buddhist beliefs and images on Japanese shores during the 6th century had a startling effect. The Japanese had long honored ancient Shinto beliefs, which invested certain places and natural objects with the supernatural power of the gods, called *kami.* But there were no images of kami until the advent of Buddhism. Then gradually, over two to three centuries, Japanese artists began to develop visual representations of these **Shinto Deities.**

87 *Shinto Deities,* 800s–900s
Japan

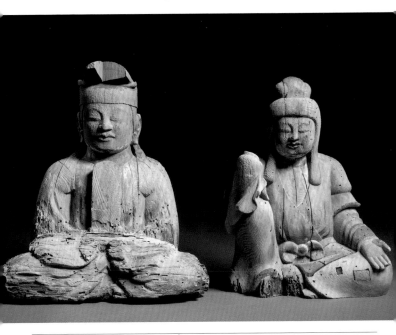

Here, a male and female god are portrayed as high-ranking aristocrats in formal court attire. Carved from a specially selected yew tree, the deities were originally painted and concealed in a provincial Shinto shrine, away from public view.

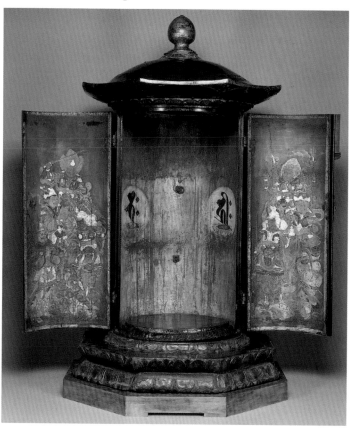

88 *Buddhist Tabernacle*, late 1100s
Japan

88 During the late Heian period (AD 794–1185), the Buddhist world was one of great splendor and mystery. It was also a fearful place that predicted a fiery and imminent end of the world. This rare **Buddhist Tabernacle,** which would have been placed in a temple, is one part of the only pair of such objects known in Japanese art. When the tabernacle doors were opened, devotees could view hundreds of handwritten holy texts (*sutras*) promising salvation. Layers of colored lacquer decorate as well as protect the wooden cabinet. Richly patterned guardians painted in reds, greens, and gold with applied designs of cut gold leaf adorn the inner doors.

89 *Zen Master Hotto Kokushi,* about 1286 Japan

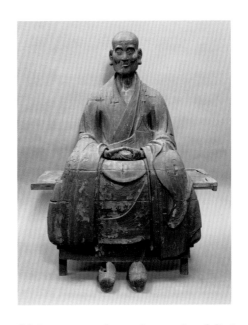

89 Japanese sculptured portraits of distinguished Buddhist priests are among the finest examples of realistic portraiture in world art. Depicted here in a cross-legged, meditative pose is the revered **Zen Master Hotto Kokushi** (1203–95). Known as Kakushin, he traveled twice to China to study Zen Buddhism. Decades of the intense meditation advocated by the Zen sect seem etched on the scholar's aged, ascetic face. Kakushin founded or rehabilitated a number of temples in rural Japan, where three sculptural portraits (*chinsō*) of him are still venerated. This austere image consists of thinly carved pieces of wood joined together by iron clamps—now visible in certain areas—then covered by layers of hemp and black lacquer.

90 *Storage Jar,* 1400s Japan

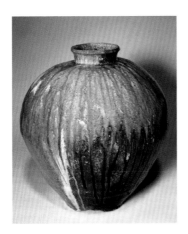

90 Clay storage jars played an integral role in the medieval, largely agricultural economy of Japan. Made during the 15th century in Echizen, a major pottery center along the Sea of Japan's fertile coastline, this large **Storage Jar** probably held rice and other grains. Its natural, rugged beauty reflects, in part, its method of production. Each jar was made by hand, section by section, by

piling coils of clay on top of one another, pinching them together, then paddling the walls with a wooden spatula. The firing process took as long as two weeks, which allowed the wood ash glaze to seal the container walls as well as to produce such rich, lustrous colors.

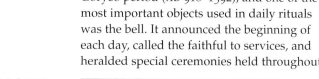

91 With the fall of China's Ming dynasty in 1644, the porcelain industry in Japan expanded dramatically to fill the vacuum in wares exported to Europe. At the same time, new porcelain types appeared, finding favor at home. An example is this *Kutani* ware, whose bold decoration covers the entire surface of the oversized **Plate with Persimmon Branch Design.** Its design features a truncated, blue persimmon branch sprouting bright green leaves against a background of mustard yellow ferns. Although the potters, decorators, and patrons of Kutani porcelain remain unknown, the exuberant ware is among the most coveted of all Japanese porcelains.

91 *Plate with Persimmon Branch Design,* late 1600s Japan

92 Buddhism flourished in Korea during the Goryeo period (AD 918–1392), and one of the most important objects used in daily rituals was the bell. It announced the beginning of each day, called the faithful to services, and heralded special ceremonies held throughout

92 *Bell,* 1200s Korea

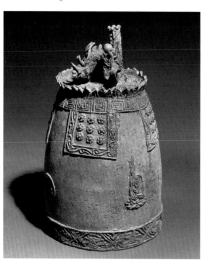

the year. This cast bronze **Bell** hung prominently in the main hall of one of the many new temples built as Buddhism spread. Unlike Western bells, Asian counterparts rang when struck on the exterior surface with a wooden mallet. A uniquely Korean feature is the vertical tube on top of the bell, next to the dragon-shaped "hook" used for suspension, that amplified the sound of the bell. Additional surface detail includes raised rosettes, seated Buddhist deities, and an inscription.

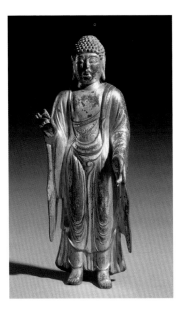

93 *Amitabha,*
800s
Korea

93 Buddhism reached the Korean peninsula from China in the 4th century, and by the time of its unification under Silla leadership in AD 668, the faith was fully embraced. Korean artisans, who were exceptional metalworkers, began producing masterful Buddhist icons to which the devout could pray. This robust figure represents **Amitabha** (Amit'a in Korean), whose promise of rebirth in paradise by reciting a simple prayer made the Buddhist deity extremely popular during this period. The warm facial expression reflects the gentle compassion of Amit'a, but the relatively plain drapery and its detailing, coupled with the stout physique, show how native Korean styles intermingled with international traditions.

94 Although Buddhism fell out of official favor in Korea during the Joseon period (1392–1910), the faith was so firmly entrenched in daily life that popular support continued. This rare gilt-bronze **Amit'a Triad** features as the central figure the Buddha of the Western Paradise, a popular Buddhist deity who promised rebirth in paradise for the faithful. Amit'a rests on a lotus flower base seated in a cross-legged meditative pose holding his hands and fingers in a gesture of blessing. He is flanked by two compassionate deities, Chijang Bosal on his right and Kuanum Bosal on his left.

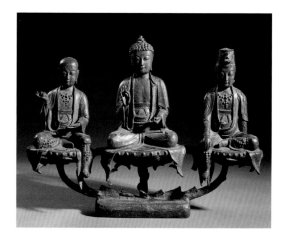

95 A taste for more casual design and robust form defines ceramics produced during the early Joseon period (1392–1910), perhaps reflecting the impact of the earlier 13th-century Mongol invasion. Three separate surface designs characterize this *punch'ong,* or stoneware, **Storage Jar.** The designs of the bottom two registers consist of sketchily rendered lotus petals followed by leaves, tendrils, and branches. They were first carved into the clay body, then filled with clay slip (a mixture of clay and water) that, when fired, turned white. An impressed "rope-curtain" pattern adorns the remainder of the jar, which was probably used for the burial of placenta, or afterbirth, an aristocratic custom thought to bring happiness to the child.

95 *Storage Jar,*
1400s
Korea

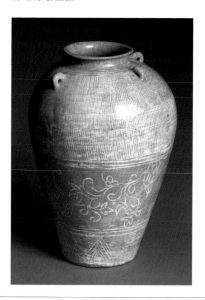

India, Himalayas, Southeast Asia

The Cleveland Museum of Art has an extensive collection of Indian and Southeast Asian sculpture, Himalayan sculpture and paintings (*thangkas*), Indian miniature paintings, and decorative art. The Indian collection concentrates on the "classical period" of Indian art from the time of the earliest historical dynasties (3rd century BC) through the medieval period (14th century). Indian paintings cover the 16th through the 19th centuries. The Southeast Asian and Himalayan collections highlight the early periods from the 6th to the 13th centuries in Southeast Asia and from the 8th through the 15th centuries in the Himalayas.

96 Sculptures seem alive, swelling with *prāna*, or "inner breath," during the Gupta period (AD 320–about 550), known as the golden age of Indian art. As in Western classical tradition, the emphasis was on idealized beauty of a spiritual as well as a physical nature. This incomplete **Standing Buddha** sways to the side in a graceful *tribhaṅga* or "three-bent" posture, displaying elegant and elongated proportions. A transparent monastic garment reveals the rounded, supple body, while the right arm offers a gesture of giving. The sculpture is made in the buff-colored sandstone characteristic of the Sarnath school, one of the most active centers of production during the Gupta period.

96 *Standing Buddha*, 400s India

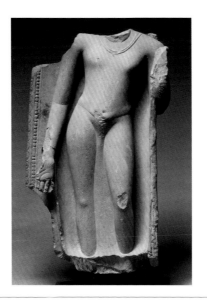

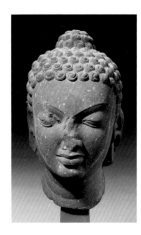

97 Artists of the Gupta period (AD 320–about 550) sought to balance spiritual beauty with physical perfection. Although the oval-shaped face and sensuous, well-defined features of this **Head of Buddha** express a physical ideal, it is the spirituality of the serene, contemplative, and compassionate expression that is emphasized here. Heavy, half-closed lids convey a feeling of concentration, implying meditation. A subtle smile of understanding lights up the face.

Reminders that Buddha was a historic person—Prince Siddhartha Gautama, born around 563 BC—are the (now broken) earlobes, once elongated from heavy princely earrings, and the tight, snail-shell curls left after he cut his long, flowing hair.

97 Head of Buddha, 400s India

98 Shiva is one of the three major gods in the divine trinity of Hinduism. Here he is represented as **Nataraja, Lord of the Dance,** who both destroys and creates the universe, caught in the midst of his cosmic dance. The ring of fire

98 Shiva Nataraja: Lord of the Dance, 11th century South India

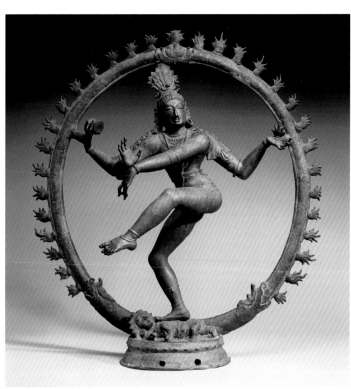

encircling him symbolizes the world's destruction, as does the flame held in his upper left hand. But the drum held in his upper right hand signifies creation. A third hand gestures "fear not," while a fourth points down to his foot, promising salvation. Produced in South India during the Chola period (10th–13th century), this lively, rhythmic bronze represents Hindu art at its peak.

99 During the medieval (or Hindu) dynasties from the 6th century onward, the long-popular theme of the amorous couple, or *Mithuna,* frequently became highly erotic. This exuberant sculpture of **Lovers** decorated the exterior walls of a temple in Khajuraho in central India. A bearded man bends over to kiss his voluptuous partner as his hand slips down her transparent muslin skirt to disrobe her. The twisting motion of the woman's body and angular placement of her arm reflect the couple's passion. Known for their erotic sculpture, the temples of Khajuraho, like all Hindu temples, were favorite community meeting places. Sculptures such as this one reflect medieval Hindu society, in which the

99 *Lovers,* 11th century India

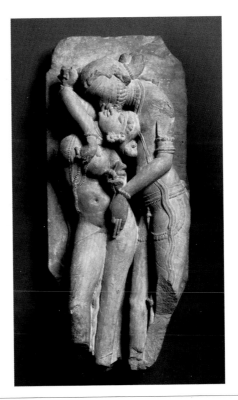

Kama Sutra, a love manual, was a popular book and temple prostitution was a fact of life. On a symbolic level, however, this imagery is frequently seen as signifying the union of worshippers with the divine.

100 Some of the most spectacular bronzes produced in the Indian world have come from Kashmir, in the northern part of the Indian subcontinent. This **Standing Buddha** bears a Tibetan inscription: "Lha-tsun [or 'god-monk,' a title used for some monks of the royal lineage] Nagaraja" [the son of Yeshes'od, the king of the ancient Guge Kingdom in the Western Himalayas]. Nagaraja was active between AD 998 and 1026, when this bronze was cast. He probably commissioned the image in Kashmir and had it brought to Western Tibet where it was inscribed with his name. It is one of the largest and most important Kashmiri bronzes to survive to this day.

100 *Standing Buddha*, 998–1026 Kashmir

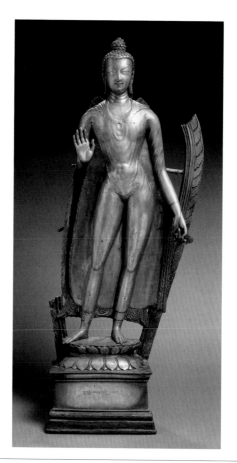

101 *Green Tara,* about 1250–1300 Tibet

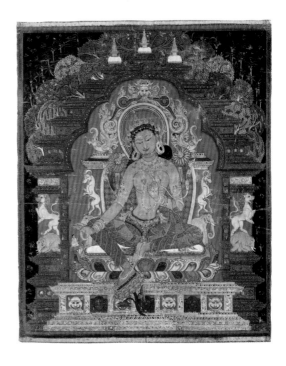

101 As the country where Buddhism and Hinduism originated, India served as great inspiration for other Asian cultures where these faiths flourished. Although this vividly colored *thangka,* or temple banner, was made in Tibet, the style of painting shows a strong eastern Indian and, at the same time, Nepalese influence. This not only indicates an early date for the **Green Tara,** when the influence of the Pala style of eastern India was dominant, but also suggests that the painting belongs to the period when the Nepalese Newari influence was particularly strong in Tibet. The studio of the greatly admired Nepalese artist Aniko was active there around the 1260s. The Green Tara, a personification of wisdom, was a popular deity because she offered protection and salvation to her devotees.

102 This statue represents the Hindu deity **Krishna** as he lifts Mount Govardhana to provide shelter for his followers from torrential rains and flooding. Accordingly, he is considered the savior of mankind. The tall, joyous statue is one of the few surviving works in Cambodia's Phnom Da style (about AD 500–550), a prototype for all subsequent Cambodian sculpture. With its sense of physicality and spiritual vibrancy, the statue reflects the great influence of classical Indian Gupta style (AD 320–about 550). When acquired by the museum, the lower portion of the body was missing. However, as a result of research, the missing fragments were found and the statue restored to its present condition.

102 *Krishna, about 500–550 Cambodia*

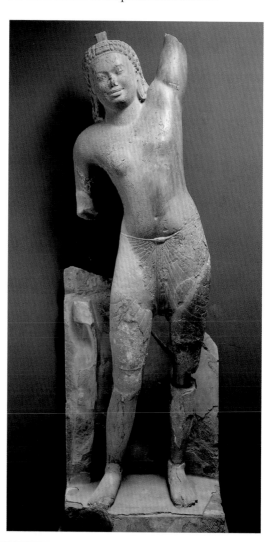

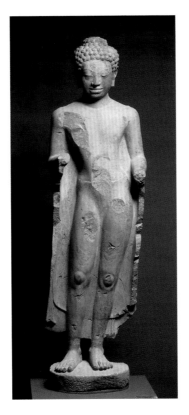

103 Were it not for the Thai facial features of this **Standing Buddha,** the sandstone statue might be mistaken for a product of India's Sarnath school of the Gupta period (AD 320–about 550). The Buddha stands in a graceful *tribhaṅga* or "three-bent" posture, expressing an ideal beauty that is both spiritual and physical. Although the hands are missing, the arm positions indicate that the right one was held up in the traditional gesture of blessing, while the left hand held the hem of his transparent monastic robe. Details of physiognomy are extremely refined, as is the rendering of the kneecaps, the collarbone, and cleavage in the center of the chest. A unique feature is the fully modeled back with its subtly curved spine.

Art of the Americas

The indigenous American collection, though small in relation to others in the United States, is noted for its quality. It includes about 850 objects representing the three major pre-Columbian culture areas—Mesoamerica, Central America, and Andean South America—from the time that complex culture emerged until the Spanish conquest in the mid 16th century. Of the three, the Mesoamerican collection is the largest, its strength lying in Classic Period arts, particularly those of the Maya and of the Veracruz ceremonial ballgame. In addition to the pre-Columbian world, the collection represents both ancient and ethnographic arts of native North America.

104 *Seated Figure,* about 300 BC–AD 500 Mexico

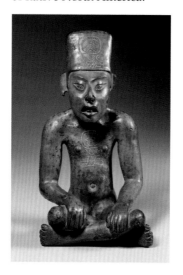

104 Based at their hilltop capital, Monte Albán, in southwestern Mexico, the Zapotec people prospered between 200 BC and AD 700. Their rulers were buried in large tombs lavishly furnished with colorful murals and many cer-amics. The most famous ceramics are figural urns possibly representing either deities or semi-divine royal ancestors and their *acompañantes* (companions), smaller, flanking sculptures similar to this **Seated Figure.** Hieroglyphs on the figure's headdress ("13 Water") and chest ("13 Flint Knife") record the names of days in the calendar. Since it was common to take significant calendar dates as names, the hieroglyphs may identify the figure.

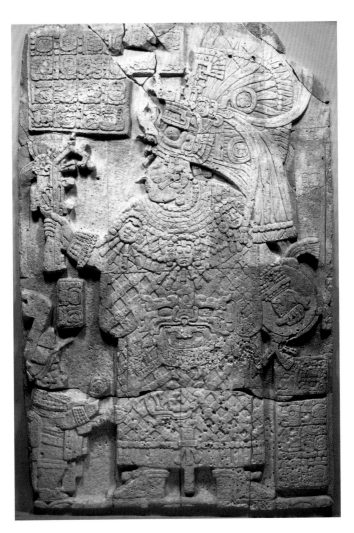

105 *Front Face of a Stela*, about 692 Guatemala

105 In much of their stone sculpture, Maya rulers in southern Mesoamerica celebrated the milestones of their reigns with idealized, flamboyant portraiture like this imposing image of a royal woman, the **Front Face of a Stela.** This monument, made around AD 692, marked the passage of a 20-year period known as the *k'atun,* an important ritual event. The stela originally stood in an open plaza between depictions of men—one of them probably the woman's husband, a ruler. Her monument's central position in the sculptural ensemble, as well as her resplendent gown, jewelry, and plumed headdress, proclaim her importance. According to hieroglyphic texts, family ties determined the woman's status: she belonged to a

dynasty more powerful than her husband's, and through marriage he probably gained potent allies. Whether the woman held more than symbolic power is not known.

106 Between AD 600 and 1000, the peoples of northwestern Honduras produced white marble **Carved Vessels,** a few of which have been found in tombs. Little is known of their uses or the meaning of the delicate, low-relief designs that grace their exteriors. Several

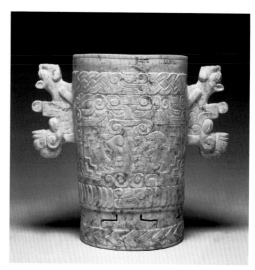

106 *Carved Vessel, about 600–1000 Honduras*

motifs are typical, including scrolls, braids, felines, and grotesque heads. In this unusually large example, these motifs multiply to create a complex and refined design in which a grotesque head is important. The main design panel, for instance, is dominated by a front-facing version of the head that hovers over two disembodied legs, the knees rendered as sharp, outward-oriented points. Beside each leg is an animated (and rare) human figure.

107 Forms of a ballgame were played at many times in Mesoamerica, but only between AD 600 and 1100 were articles of ballgame equipment translated into works of art. For instance, this stone **Ballgame Yoke**—inaccurately so named because of its resemblance to oxen yokes—imitates a belt worn to deflect the solid rubber ball during play. (Apparently hands and feet were not used to propel the ball.) Perhaps worn

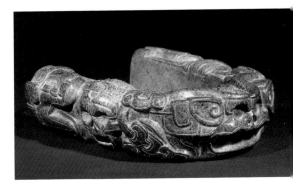

during game-related ceremonies, the yoke is made of serpentine, with traces of cinnabar still on its surface, and carved with a grotesque head, skulls, and entwined rattlesnakes. As this imagery suggests, the ballgame was not merely sport but a profound ritual activity; reliefs from the period suggest the game linked fertility, or life, to sacrifice, or death.

108 Between about AD 300 and 1100, peoples of western Costa Rica buried elaborate ceramics, like this **Lidded Bowl,** in the tombs of their honored dead—some of them undoubtedly chieftains. The plump, sleek iguana perched on the lid probably holds symbolic value. In many parts of the intermediate region, both today

108 *Lidded Bowl,* about 300–1100 Costa Rica

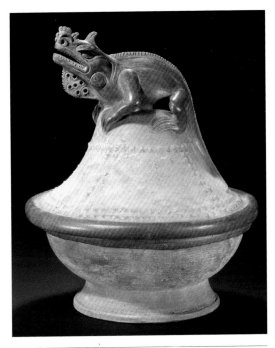

and in the past, iguanas have rich mythologies that often link them to the sky and to concepts of rulership. It is probably not coincidence then that the lizard here poses as though basking in the sun—a celestial body—and displays behaviors that establish dominance: the teeth bristle menacingly, and the dewlap (the semi-circular flap under the chin) is fully fanned and rigid.

109 This Panamanian **Plaque with Reptilian Being,** probably a chest ornament, comes from the grave of a young chief whose status was stunningly documented by the 21 human companions and hundreds of other objects buried in his tomb in the latter half of the first millennium. The plaque displays the image of a being with reptilian traits—including clawed digits and head emanations—perhaps based on an iguana's crest or on crocodile scutes

109 *Plaque with Reptilian Being,* about 700–900 Panama

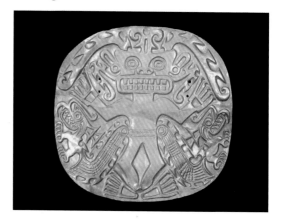

(bony plates). Perhaps a deity, perhaps a costumed human or mythic character, the creature clearly is intended to convey power, a message reinforced by the lavish use of gold. As in later periods, both the warm gleam of gold and reptilian imagery may have linked rulers with the sun's generative force.

110 An ornament suspended from the hole at its top, this **Plaque** probably comes from a grave on Peru's North Coast. Its imagery, however, derives from Chavín, a powerful highland religious center that, between 900 and 200 BC, developed one of the most sophisticated early Andean art styles. The religion of Chavín was exported to many areas, a process traced

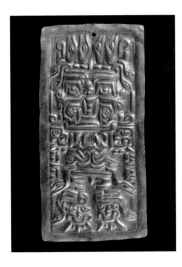

through the distribution of portable, often finely made objects. These works depict Chavín religious imagery—here a feline-like deity with a fanged mouth and clawed feet and hands. From Chavín came the first complex metallurgical technologies in the Andes, used to create the first large metal objects. It may be that these revolutionary objects helped to express the inexpressible nature of Chavín religion.

110 *Plaque,*
about 400–300 BC
Peru

111 The identity of this **Female Figure** is mysterious. However, in others of this kind, the heads of supernatural beings are painted on the pubis and fleshy buttocks, suggesting a connection to the sacred and a concern with fertility, as does the figure's ampleness. Fat implies abundant food and agricultural success, a problem for the Nasca, who lived in the deserts of Peru from about 100 BC to AD 700. The tapered head reflects the deliberate Nasca practice of cranial shaping during infancy, a mark of group identity and perhaps of beauty. Though the figure, which originally might have worn small cloth garments, may last have served as a grave offering, any previous function is unknown.

111 *Female Figure,* about 100 BC–AD 600 Peru

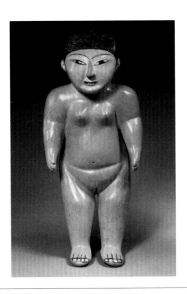

112 This **Figure in a Litter** may represent a deity, a revered ancestral mummy, or a masked human dignitary of the Wari state that flourished in Peru from about AD 500 to 900. The sculpture's body is human, but the face bears traits typical of mythical creatures: the eyes are divided vertically and N-shaped fangs inset in the mouth. The figure wears a garment patterned with circles that may refer to tie-dyeing, and its hands cup around holes that once probably held scepter-like staffs, enduring symbols of human and divine authority in the Andes. This powerful personage sits upon a litter, a mode of travel probably reserved for those of high station. The knobs on the litter refer to poles that rested on the shoulders of human bearers.

113 *Face Mask,* 1800s North America

113 In 1998, Robert Joseph, a chief of the Kwakwaka'wakw (one of the native groups of the Northwest Coast), recalled that when he donned ceremonial dance masks as a youth, "all the world is somewhere else. . . I am the mask. I am the bird. I am the animal. I am the spirit. . . I transcend into the being of the mask." Although this human **Mask** was created by an earlier artist of the Tlingit, Joseph's words both hint at masks' general purpose, which is to help make the supernatural world visible, and remind us that ceremonial traditions continue today. The specific identity and use of this mask are lost; it may represent a mythic ancestor of a Tlingit family, worn during a winter ceremony.

114 Nancy Youngblood descends from several generations of female potters of the Santa Clara Pueblo in New Mexico, and one of her deeply felt goals is to preserve and perpetuate the traditional ceramic forms and methods of her predecessors. This **Carved Vessel,** for instance, takes inspiration from the Pueblo's typical fluted, gourd-shaped ceramics. However, the exterior is deeply hand-carved with 32 parallel ribs that demonstrate masterful control and have become Youngblood's distinctive artistic signature. The vessel is not glazed; instead, the firing technique gives the black color. The lustrous surface is achieved by hand-polishing with smooth, river-washed stones; two to three hours are required to polish as many ribs.

114 *Carved Vessel, 1994* Nancy Youngblood

Prints

The collection of about 15,000 prints provides a comprehensive survey of printmaking in the West, from its beginnings in the mid 15th century through the present day, plus 20th-century Japanese prints. The holdings comprise a group of Italian and German late 15th-century engravings, works of Albrecht Dürer and Rembrandt van Rijn, and many 16th-century woodcut masterpieces. Other strengths include large groups by James McNeill Whistler, Charles Meryon, and George Bellows, and a selection of 19th-century lithography by such masters as Odilon Redon, Édouard Manet, and Henri de Toulouse-Lautrec.

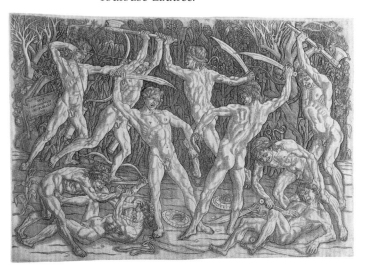

115 *Battle of the Nudes,* about 1470–75
Antonio Pollaiuolo

115 Monumental in size and conception, **Battle of the Nudes** from the late 15th century is the first Italian engraving inscribed with the artist's full name and the only known print by Florentine sculptor, painter, designer, and goldsmith Antonio Pollaiuolo. The subject of this revolutionary representation of physical striving remains uncertain—although an interest in anatomy, a demonstration of drawing skills, and references to mythological, historical, and religious sources have all been suggested. The effective description of real and fictional musculature and the variety of active poses presented from different points of view made this print a popular and influential resource for other artists. The museum's print is the earliest known impression, before the engraving plate

was reworked (possibly by another hand), and lost its subtle, silvery surface.

116 The grand scale and radical reworking of **The Three Crosses (Christ Crucified),** finished in 1660, marks the culmination of Rembrandt van Rijn's career as a printmaker. A ceaseless experimenter, the great Dutch artist often made changes in his plates (creating different "states") or selectively wiped the ink between printings, resulting in varied impressions of an image. The museum's impression of the fourth and final state reflects the personal and spiritual vision that Rembrandt brought to many of

116 *The Three Crosses,* 1653–60 Rembrandt van Rijn

his late religious subjects. He obscured details to emphasize the primordial darkness that covered the land, the crucified Christ (bathed in a sheath of light), and the ensuing chaos. Rather than conform to a traditional narrative approach, Rembrandt created an inventive and expressive drama.

117 The Norwegian artist Edvard Munch experimented constantly, inventing unusual ways to use traditional techniques and developing new procedures to achieve his expressive purposes. He exploited the grain of the block of wood to add texture and pattern to prints. This impression of **Melancholy**—printed in black and then extensively hand-colored—seems to be the only one printed from this particular

woodblock. It was probably produced between the other two woodcut versions of the same theme executed in 1896 and 1901. The scene depicts Munch's friend, the Danish art critic Jappe Nielsen, sitting on the shore at Åsgårdstrand, brooding on the marriage of the woman he loves to another man. The couple is represented by only a few lines in the background near the boat.

117 *Melancholy,*
about 1896
Edvard Munch

Drawings

The drawing collection numbers about 2,700 sheets and includes works from the early Renaissance through the postwar era. It is almost evenly divided between European and American schools, with about 600 pieces by artists working in Cleveland. The collection is small by international standards but includes key drawings by Fra Filippo Lippi, Michelangelo, Albrecht Dürer, Rembrandt van Rijn, Jean-Honoré Fragonard, and Georges Seurat; watercolors by J. M. W. Turner and Winslow Homer; pastels by Edgar Degas and Odilon Redon; and modern masterpieces by Pablo Picasso, Egon Schiele, Charles Sheeler, and Jasper Johns.

118 This drawing is a study for one of the monumental nude figures on Michelangelo's painted ceiling in the Sistine Chapel in Rome, finished in 1512. The idealized male torso reflects the Renaissance revival of classical models and its emphasis on the beauty of the human form. Michelangelo rendered the musculature of the **Nude Youth** with precise strokes of chalk, capturing the light falling on the body. He used the back of the sheet to make studies of the foot for the same figure.

118 *Study for Nude Youth,* 1511–12 Michelangelo Buonarroti

119 *Arm of Eve,* 1507
Albrecht Dürer

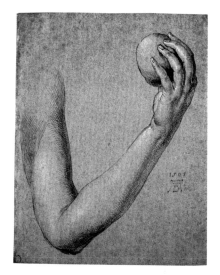

119 The **Arm of Eve,** dated 1507, is the only known study for Albrecht Dürer's pair of life-size panel paintings of Adam and Eve in the Prado Museum in Madrid. It is a meticulous study of light and shadow that masterfully captures the surface contour of an arm. The use of blue paper, which the German artist picked up during a trip to Venice, allowed him to model effectively with both white and black lines, using the blue color as a middle tone.

120 *Invocation to Love,* about 1781
Jean-Honoré Fragonard

120 Jean-Honoré Fragonard's lighthearted scenes of love and courtship in garden settings reflect the joyful spirit of 18th-century French

rococo style. **Invocation to Love** was completed around 1781, one of four versions of the same subject, both painted and drawn. Fragonard's rapid, virtuoso draftsmanship evokes forms that seem to move beneath shimmering veils of brown wash. His freedom of style echoes the drawing's subject of love unleashed. A swooning woman seems desperate for the aid of the blindfolded cupid statue, but the sad expression of the winged putto on the left suggests a less than joyous outcome.

121 In the late 1950s, in a loft in lower Manhattan, Jasper Johns achieved a paradoxical kind of realism by using imagery so banal and familiar that, like the numbers in **Ten Num-**

121 *Ten Numbers,*
1960
Jasper Johns

bers, the objects are not so much represented as simply present. Media in his work are used with the same objectivity; everything remains itself. We are forced to concentrate on the rich, varied surfaces of these drawings, a sensuous inventory of possible marks in charcoal. Further, we must reconsider representation as a way of understanding art: the meaning of an image is inseparable from its physical reality, or, in the case of *Ten Numbers,* from an established system.

Photography Covering the history of the medium from its beginnings in 1839 to the present day, the Cleveland Museum of Art's collection contains works by many exceptional photographers. This growing collection of more than 4,200 individual and gravure prints is bolstered by significant holdings of such noted practitioners as Margaret Bourke-White, Adolphe Braun, Julia Margaret Cameron, Ray K. Metzker, Louis-Rémy Robert, Cervin Robinson, Alfred Stieglitz, Paul Strand, William Henry Fox Talbot, Clarence H. White, James VanDerZee, and Minor White, as well as complete sets of the photographic publications *Camera Work* and Edward S. Curtis's *The North American Indian*.

122 *Articles of Glass*, 1843 William Henry Fox Talbot

122 In 1839, the educated English country gentleman William Henry Fox Talbot laid the foundation for modern photography with his invention of the first negative-positive photographic process. Suddenly, one could produce an infinite number of prints from a single paper negative of, for example, the calotype shown here. **Articles of Glass** depicts three rows of sparkling glassware from Constance Talbot's shelves, revealing the new medium's capacity for recording reality in areas of light and dark. Talbot—whose eclectic interests included language, mathematics, and botany—also wrote seven books. Among them was *The Pencil of Nature*, one of the first books illustrated with actual photographs, including this image.

123 Fleeing his native Hungary after a failed revolution, the activist Lázló Moholy-Nagy became an avant-garde artist and theorist who relied in his photography on unusual vantage points, distorted angles, and extreme close-ups. In this arresting image of the **Eiffel Tower** Moholy-Nagy looked up at the structure, letting light and shadow transform the familiar iron framework into a dynamic, abstract pattern of curved and straight lines. His use of the revolutionary new Leica camera—which took quick, spontaneous shots in the available light —also helped capture the complex vitality of the modern city.

123 *Eiffel Tower, Paris*, 1925
Lázló Moholy-Nagy

124 *San Zaccaria,*
Venice, 1995
Thomas Struth

124 In 1989, German artist Thomas Struth be-
gan a series of large-scale color photographs of
people visiting art museums around the world.
For this immense, brilliantly colored image of
the interior of **San Zaccaria,** a church in Venice,
Struth set his camera at eye level, focusing
directly on Renaissance artist Giovanni Bellini's
central altarpiece of 1505. Among the ironies
caught on film are the incongruous poses of
visitors dwarfed by art and architecture once
intended for spiritual purposes but now func-
tioning more as a museum. Also implicated is
the viewer of the photograph, who looks at
art about looking at art, thus acting as a voyeur.

Textiles

The Textile Department's holdings of about 4,500 items are drawn from around the world and date from 500 BC to the present. The collection's strengths include Pre-Columbian textiles, medieval and Renaissance Italian silks, French silks, lace, Coptic textiles, Islamic textiles, medieval Central Asian and Chinese silks, and contemporary fiber art. Textiles are displayed with culturally related art throughout the museum.

125 This painted cloth, created by the Nasca people of Peru's South Coast, is among the most famous of surviving ancient Andean textiles. It displays a magnificent **Procession of Figures** who may be deities or humans impersonating deities. Several wear forehead ornaments and feline mouth-masks like the gold ex-

125 *Cloth with Procession of Figures,* 100 BC–AD 200 Peru

amples recovered from Nasca graves. Although the procession's purpose is not clear, it may have been associated with promoting nature's fertility. The function of the cloth is uncertain, and it is incomplete along the upper edge.

126 This luxurious, brightly colored **Child's Coat** is the only garment of its type known to have survived. The design—consisting of pairs of ducks standing on split palmetto leaves encircled with pearls—symbolizes royalty and is typical of 8th-century silks made in Sogdiana, a confederation of city-states in the vicinity of today's Uzbekistan in west-central Asia. Silk garments like this coat were so valuable that they were often

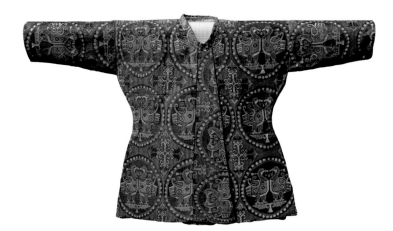

126 *Child's Coat, 700s Central Asia*

given as imperial gifts or used as a form of currency. A pair of monochrome damask trousers, made to be worn with the coat, is also in the museum's collection.

127 The exceptional quality of this embroidered **Kayasha** (Buddhist priest's ceremonial robe) of colored silks and gold threads indicates that it was made in a royal workshop in China during the early Ming dynasty (1368–1644), perhaps as an imperial gift. Hundreds of colorful appliquéd Buddhas in a variety of poses decorate the robe to represent the Buddha's limitless, cosmic consciousness. Reserved for special ceremonial occasions, the robe was worn only by the highest priest of the monastery, who would drape its almost ten-foot width around his body, securing it in the front with ties.

127 *Kayasha, 1403–24 China*

128 This immense silk **Curtain** is thought to have adorned the Alhambra, the lavish palace built by the Nasrid dynasty (1231–1492), the last Muslim rulers in Granada, Spain. Composed of two unusually wide lengths joined by a narrow vertical band, the curtain contains patterns resembling those of stucco wall decorations in the Alhambra. These designs juxtapose angular and curvilinear motifs in a dynamic harmony, a hallmark of the finest Islamic art. Also characteristic is the incorporation of Arabic inscriptions, conveying, among other things, wishes for good fortune. The prominent use of yellow silk thread possibly dates the curtain after about 1414, when Muslim weavers stopped using costly gold-wrapped silk thread so as not to drain the economy.

129 *Patolu,*
mid-1800s
India

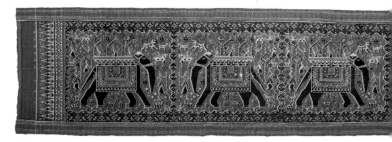

TEXTILES

129 India is renowned for its centuries-old production of colorful textiles made specifically for export, prized in the East as well as the West. This double *ikat* silk cloth, or **Patolu,** was the most prestigious of its kind exported to Indonesia, where such textiles were considered sacred heirlooms. The rare cloth was used only for the most important ceremonial occasions, probably as a banner or hanging. The four huge elephants carry small figures upon their backs against a lively, decorative background. The colorful, intricate pattern was made with the time- and labor-intensive double ikat technique, in which silk warp and weft threads were repeatedly tied and dyed with the pattern before being woven.

130 To show off their extraordinary skill, French textile manufacturers produced remarkably complex shawls for display at large national and international fairs beginning around 1830. This long silk **Shawl** may have been

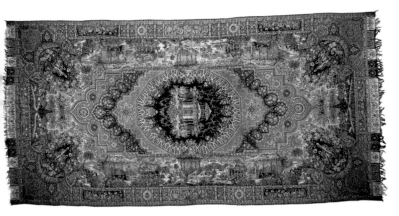

130 *Shawl,* 1867
France

exhibited at the Paris Universal Exhibition of 1867 and then presented to French Empress Eugénie (reigned 1853–70). A technical tour de force, the shawl uses more than 20 colors to combine a variety of large patterns and the intricate imagery of idyllic scenes of East and West. Woven on a jacquard loom (invented in 1801), the shawl would have been worn as outerwear wrapped elegantly around the large skirts that were so fashionable at the time but too expansive to fit beneath a coat.

Information about the Works of Art

1. *Statuette of a Woman: "The Stargazer,"* about 3000 BC. Probably from western Anatolia. Marble; h. 6¾ in. Leonard C. Hanna Jr. Fund; John L. Severance Fund 1993.165

2. *Winged Genie Pollinating Date Palm,* 875–860 BC. Iraq, Nimrud, Assyrian, reign of Ashurnasirpal II. Alabaster; 98 x 61 in. Purchase from the J. H. Wade Fund 1943.246

3. *Bowl: King Hormizd II or Hormizd III Hunting Lions,* AD 400–600. Iran, Sassanian. Silver gilt; diam. 8¼ in. John L. Severance Fund 1962.150

4. *Statue of Amenemhat III,* 1859–1814 BC. Egypt, Middle Kingdom, Dynasty 12, reign of Amenemhat III. Granodiorite; h. 20⅛ in. Purchase from the J. H. Wade Fund 1960.56

5. *Head of Amenhotep III Wearing the Round Wig,* 1391–1353 BC. Egypt, New Kingdom, Dynasty 18, reign of Amenhotep III. Brown quartzite; h. 6⅞ in. Leonard C. Hanna Jr. Fund 1961.417

6. *Nome Gods Bearing Offerings,* 1391–1353 BC. Egypt, New Kingdom, Dynasty 18, reign of Amenhotep III. Painted limestone; 26 x 52⅜ in. John L. Severance Fund 1961.205; 1976.51

7. *Statue of Minemheb,* 1391–1353 BC. Egypt, New Kingdom, Dynasty 18, reign of Amenhotep III. Granodiorite; h. 17¾ in. Leonard C. Hanna Jr. Fund 1996.28

8. *Coffin of Bakenmut,* about 1000–900 BC. Egypt, Third Intermediate Period, late Dynasty 21–early Dynasty 22. Gessoed and painted sycamore fig; l. 82 in., w. 26¾ in. Gift of the John Huntington Art and Polytechnic Trust 1914.561.a–b

9. *Kouros,* 575–550 BC. Greece. Marble; h. 24⅝ in. Gift of the Hanna Fund 1953.125

10. *Statuette of an Athlete,* 510–500 BC. Greece, Peloponnesus(?). Bronze; h. 8½ in. John L. Severance Fund 2000.6

11. Attributed to Douris. *The Atalanta Lekythos,* 500–490 BC. Greece, Attic. Painted white-ground terracotta; h. 12½ in. Leonard C. Hanna Jr. Fund 1966.114

12. Attributed to the Meidias Painter. *Red-Figure Squat Lekythos with the Birth of Erichthonios,* about 410 BC. Greece, Attic. Earthenware with slip decoration and gilded relief; h. 12 in. Leonard C. Hanna Jr. Fund 1982.142

13. *Cista Handle: Sleep and Death Carrying off the Slain Sarpedon,* 400–375 BC. Italy, Etruscan. Bronze; h. 5½ in. Purchase from the J. H. Wade Fund 1945.13

14. *The Emperor as Philosopher, probably Marcus Aurelius,* about AD 175–200. Turkey, Bubon(?) (in Lycia), Roman. Bronze hollow cast in several pieces and joined; h. 76 in. Leonard C. Hanna Jr. Fund 1986.5

15. *The Jonah Marbles,* AD 270–80. Eastern Mediterranean, probably Asia Minor. Marble. *Jonah Swallowed,* h. 20¼ in. *Jonah Cast Up,* h. 16 in. *Jonah under the Gourd Vine,* h. 12⅝ in. *Jonah Praying,* h. 18½ in. *The Good Shepherd,* h. 19¾ in. John L. Severance Fund 1965.237–41

16. *Elements from a Constantine Necklace,* AD 324–26. Byzantium, Late Roman, Constantinian Era. Gold. *Pendant with a Double Solidus of Constantine I,* 3⅛ x 3⅝ in. each. *Spacer in the Form of a Corinthian Column,* h. 2½ in. each. *Clasp Set with Semi-precious Stones,* 1½ x 3⅛ x 2 in. Leonard C. Hanna Jr. Fund 1994.98.1–4

17. *Icon of the Virgin,* 500s. Egypt, Byzantine period. Tapestry weave; wool; 70⅜ x 43¼ in. Leonard C. Hanna Jr. Fund 1967.144

18. *Plaque with the Enthroned Mother of God,* about 1050–1200. Byzantium, Constantinople(?). Ivory; 10 x 6⅞ in. Gift of J. H. Wade 1925.1293

19. *Reliquary Cross of Countess Gertrude; Reliquary Cross of Count Liudolf Brunon,* about 1038–40. Germany, Lower Saxony, Hildesheim. Gold, cloisonné enamel, gems, pearls, and mother-of-pearl on a core of oak; h. 9½ in. each. Purchase from the J. H. Wade Fund with the addition of a gift from Mrs. Edward B. Greene 1931.55; Gift of the John Huntington Art and Polytechnic Trust 1931.461. *Portable Altar of Countess Gertrude,* about 1045. Germany, Lower Saxony, Hildesheim. Red porphyry, gold, cloisonné enamel, gems, and pearls on a core of oak; 10½ x 4 x 8 in. Gift of the John Huntington Art and Polytechnic Trust 1931.462.a–b

20. *Crucifix with Six Scenes from the Passion,* about 1230–40. Italy, Pisa. Tempera and oil with gold on wood; h. 72⅞ in. Leonard C. Hanna Jr. Fund 1995.5

21. *Christ and Saint John the Evangelist,* early 1300s. Germany, Swabia near Bodensee (Lake Constance). Polychromed wood; h. 36½ in. Purchase from the J. H. Wade Fund 1928.753

22. *Table Fountain,* about 1300–1350. France, Paris(?). Gilt-silver and translucent enamel; h. 12¼ in. Gift of J. H. Wade 1924.859

23. *The Gotha Missal,* about 1375. France, Paris. Ink, tempera, and gold on vellum; 10⅝ x 7⅝ in. Mr. and Mrs. William H. Marlatt Fund 1962.287

24. Master of Heiligenkreuz (Bohemian). *Death of the Virgin,* about 1400. Tempera and oil with gold on wood; 26 x 21 in. Gift of the Friends of The Cleveland Museum of Art in memory of John Long Severance 1936.496

25. Claus de Werve (Netherlandish, about 1380–1439). *Three Mourners from the Tomb of Philip the Bold, Duke of Burgundy,* 1406–10. Vizille alabaster; h. 16½ in. overall. Purchase from the J. H. Wade Fund 1940.128; Bequest of Leonard C. Hanna Jr. 1958.66–67

26. Mino del Reame (Italian). *Madonna and Child,* about 1461–75. Marble with traces of gilding; 36⅞ x 31½ in. Gift of Mrs. Leonard C. Hanna 1928.747

27. Alexander Bening and Associates (Flemish). *Hours of Queen Isabella the Catholic, Queen of Spain,* about 1497–1500. Ink, tempera, and gold on vellum; 8¾ x 6 in. Leonard C. Hanna Jr. Fund 1963.256

28. Filippino Lippi (Italian, about 1457–1504). *The Holy Family with John the Baptist and Saint Margaret,* about 1495. Tempera and oil on wood; diam. 60¼ in. The Delia E. Holden Fund and a fund donated as a memorial by her children: Guerden S. Holden, Delia Holden White, Roberta Holden Bole, Emery Holden Greenough, Gertrude Holden McGinley 1932.227

29. *Time,* 1500–1510. France. Tapestry weave; wool and silk; 133½ x 173 in. overall. Leonard C. Hanna Jr. Fund 1960.176.3

30. *Ewer,* 1540–67. France, Saint-Porchaire. Lead-glazed white-paste earthenware; h. 14 in. Purchase from the J. H. Wade Fund 1953.363

31. Andrea del Sarto (Italian, 1486–1530). *The Sacrifice of Isaac,* about 1527. Oil on wood; 70⅛ x 54⅜ in. Delia E. Holden and L. E. Holden Funds 1937.577

32. Pompeo della Cesa (Italian, Milan). *Half-Armor for the Foot Tournament,* about 1590. Etched and gilded steel, brass, leather, and velvet; h. 38½ in. overall. John L. Severance Fund 1996.299.a–l

33. Caravaggio (Michelangelo Merisi, Italian, 1573–1610). *The Crucifixion of Saint Andrew,* 1609–10. Oil on canvas; 79¾ x 60⅛ in. Leonard C. Hanna Jr. Fund 1976.2

34. Frans Hals (Dutch, about 1581–1666). *Tieleman Roosterman,* 1634. Oil on canvas; 45½ x 32½ in. Leonard C. Hanna Jr. Fund 1999.173

35. Georges de La Tour (French, 1593–1652). *Saint Peter Repentant,* 1645. Oil on canvas; 44⅞ x 37⅜ in. Gift of the Hanna Fund 1951.454

36. Alessandro Algardi (Italian, 1598–1654). *Baptism of Christ,* designed 1645/46. Bronze; h. 24⅝ in. Andrew R. and Martha Holden Jennings Fund 1965.471

37. Nicolas Poussin (French, 1594–1665). *The Holy Family on the Steps,* 1648. Oil on canvas; 28½ x 44 in. Leonard C. Hanna Jr. Fund 1981.18

38. Pierre Puget (French, 1620–1694). *Blessed Alessandro Sauli,* 1663–68. Terracotta; h. 27½ in. Andrew R. and Martha Holden Jennings Fund 1964.36

39. André-Charles Boulle (French, 1643–1732). *Clock,* about 1695. Tortoiseshell, pewter, and brass inlay, and gilt bronze; h. 44¾ in. Gift of Family and Friends in honor of Emery May Holden Norweb and Raymond Henry Norweb 1967.153

40. Juste-Aurèle Meissonnier (French, 1695–1750). *Tureen,* 1735–40. Silver; h. 14½ in. Leonard C. Hanna Jr. Fund 1977.182.a–b

41. Jean-Pierre Latz (French, 1691–1754). *Tall Clock,* 1744. Boulle marquetry with gilt-bronze mounts; h. 103⅛ in. John L. Severance Fund 1949.200

42. John Singleton Copley (American, 1738–1815). *Nathaniel Hurd,* about 1765. Oil on canvas; 30 x 25½ in. Gift of the John Huntington Art and Polytechnic Trust 1915.534

43. Antonio Canova (Italian, 1757–1822). *Terpsichore,* 1816. Marble; h. 69⅞ in. Leonard C. Hanna Jr. Fund 1968.212

44. Jacques-Louis David (French, 1748–1825). *Cupid and Psyche,* 1817. Oil on fabric; 72⅝ x 95¼ in. Leonard C. Hanna Jr. Fund 1962.37

45. Francisco de Goya (Spanish, 1746–1828). *Don Juan Antonio Cuervo,* 1819. Oil on canvas; 47¼ x 34¼ in. Mr. and Mrs. William H. Marlatt Fund 1943.90

46. Joseph Mallord William Turner (British, 1775–1851). *The Burning of the Houses of Lords and Commons, 16 October 1834,* 1835. Oil on fabric; 36¼ x 48½ in. Bequest of John L. Severance 1942.647

47. William Sidney Mount (American, 1807–1868). *The Power of Music,* 1847. Oil on canvas; 17⅛ x 21⅛ in. Leonard C. Hanna Jr. Fund 1991.110

48. Frederic Edwin Church (American, 1826–1900). *Twilight in the Wilderness,* 1860. Oil on canvas; 40 x 64⅛ in. Mr. and Mrs. William H. Marlatt Fund 1965.233

49. Herter Brothers (American). *Fire Screen,* about 1878–80. Gilded wood, painted and gilded wood panels, brocaded silk, and embossed paper; h. 51⅞ in. The Severance and Greta Millikin Purchase Fund 1997.58

50. William Merritt Chase (American, 1849–1916). *Dora Wheeler,* 1882–83. Oil on canvas; 62⅝ x 65¼ in. Gift of Mrs. Boudinot Keith in memory of Mr. and Mrs. J. H. Wade 1921.1239

51. Vincent van Gogh (Dutch, 1853–1890). *The Large Plane Trees,* 1889. Oil on canvas; 28⅞ x 36⅛ in. Gift of the Hanna Fund 1947.209

52. Edgar Degas (French, 1834–1917). *Frieze of Dancers,* 1895. Oil on fabric; 27⅝ x 79 in. Gift of the Hanna Fund 1946.83

53. Designed by Félix Bracquemond (French, 1833–1914); relief by Auguste Rodin (French, 1840–1917); enamel by Alexandre Riquet (French). *Hand Mirror,* 1900. Gold, enamel, and ivory; h. 12⅜ in. Gift of Ralph King, by exchange 1978.43

54. Paul Gauguin (French, 1848–1903). *The Call,* 1902. Oil on fabric; 51¾ x 35¼ in. Gift of the Hanna Fund 1943.392

55. Pablo Picasso (Spanish, 1881–1973). *La Vie,* 1903. Oil on canvas; 77⅜ x 50⅞ in. Gift of the Hanna Fund 1945.24

56. Designed by Carlo Bugatti (Italian, 1856–1940, active in France); manufactured by A. A. Hébrard Firm. *Table, Salver, Tea Service on Tray,* about 1907. Table: inlaid wood (mahogany?), cast and gilded bronze mounts, inlays of ivory and bone, metal, and mother-of-pearl; h. 28¼ in. Salver: silver and ivory; diam. 13 in. Tea service: silver and ivory; h. 7¼ in. overall. Tray: silver and ivory; l. 30½ in. Leonard C. Hanna Jr. Fund 1991.45–46; The Thomas L. Fawick Memorial Collection 1980.74.1–5

57. George Bellows (American, 1882–1925). *Stag at Sharkey's,* 1909. Oil on canvas; 36¼ x 48¼ in. Hinman B. Hurlbut Collection 1133.1922

58. Claude Monet (French, 1840–1926). *Water Lilies (Agapanthus),* about 1915–26. Oil on canvas; 79¼ x 167¾ in. John L. Severance Fund 1960.81

59. Pablo Picasso (Spanish, 1881–1973). *Bottle, Glass, and Fork,* 1911–12. Oil on canvas; 28⅜ x 20¼ in. Leonard C. Hanna Jr. Fund 1972.8

60. Charles Sheeler (American, 1883–1965). *Church Street El,* 1920. Oil on canvas; 16⅛ x 19⅛ in. Mr. and Mrs. William H. Marlatt Fund 1977.43

61. Salvador Dalí (Spanish, Catalan, 1904–1989). *The Dream,* 1931. Oil on canvas; 37⅞ x 37⅞ in. John L. Severance Fund 2001.34

62. Georgia O'Keeffe (American, 1887–1986). *Sunflower, New Mexico I,* 1935. Oil on canvas; 20 x 16 in. Bequest of Georgia O'Keeffe 1987.140

63. Henri Matisse (French, 1869–1954). *Interior with an Etruscan Vase,* 1940. Oil on canvas; 29 x 42½ in. Gift of the Hanna Fund 1952.153

64. Jackson Pollock (American, 1912–1956). *Number 5, 1950,* 1950. Oil on canvas; 53¾ x 39 in. Leonard C. Hanna Jr. Fund 1980.180

65. Romare Bearden (American, 1912–1988). *Wrapping It Up at the Lafayette,* 1974. Paper and fabric collage on wood; 48 x 36 in. Mr. and Mrs. William H. Marlatt Fund 1985.41

66. Anselm Kiefer (German, born 1945). *Lot's Wife,* 1989. Oil paint, ash, stucco, chalk, linseed oil. Mixed media and applied elements on canvas, attached to lead foil, on plywood panels; 137⅞ x 161½ in. Leonard C. Hanna Jr. Fund 1990.8.a–b

67. Frank Stella (American, born 1936). *Çatal Hüyük (level VI B) Shrine VI B.1,* 2001. Aluminum pipe and cast aluminum; 97 x 127 in. Gift of Agnes Gund and Daniel Shapiro and John L. Severance Fund 2001.126

68. *Antelope Headdress,* about 1920s. Mali, Bamana. Wood, beads, metal, and shells; h. 17½ in. Gift of Mrs. Ralph M. Coe in memory of Ralph M. Coe 1965.325

69. *Head of a King,* 1600s. Nigeria, Edo, Benin City. Bronze; h. 11¾ in. Dudley P. Allen Fund 1938.6

70. *Buffalo Mask,* about 1940s. Burkina Faso, Bwa. Wood, fibers, and pigment; h. 27½ in. Gift of Katherine C. White 1969.2

71. *Male Figure,* before 1930. Democratic Republic of the Congo, Basikasingo(?). Wood and cloth; h. 19 in. Gift of Katherine C. White 1969.10

72. *Mother and Child,* late 1800s–early 1900s. Democratic Republic of the Congo, Kongo (Yombe). Carved and painted wood; h. 25½ in. Leonard C. Hanna Jr. Fund 1997.149

73. *Silver Inlaid Brass Bowl,* 1200s. Iran, Seljuk period. Brass inlaid with silver; diam. 6⅜ in. Purchase from the J. H. Wade Fund 1944.485

74. *Ceremonial Spittoon or Basin,* about 1350. Syria or Egypt, Mamluk dynasty. Glass with enameled and gilded decoration; diam. 12½ in. Purchase from the J. H. Wade Fund 1944.235

75. *Carpet, called "Polonaise,"* about 1600. Iran, Kashan, Safavid dynasty. Asymmetrical knot: silk, cotton, and gilt- and silver-metal thread; 81 x 56 in. Purchase from the J. H. Wade Fund 1926.533

76. *Square Wine Bucket,* about 1100–1050 BC. China, said to be from Anyang, Henan province, Shang dynasty. Bronze; h. 10½ in. John L. Severance Fund 1963.103

77. *Drum Stand,* 300–221 BC. China, said to be from Changsha, Hunan province, late Warring States period. Lacquered wood; h. 52 in. Purchase from the J. H. Wade Fund 1938.9

78. *Stele with Shakyamuni and Bodhisattvas,* AD 537. China, Six Dynasties period, Eastern Wei dynasty. Limestone; h. 30½ in. Gift of the John Huntington Art and Polytechnic Trust 1914.567

79. *Pair of Tomb Guardians,* late 600s or early 700s. China, probably from Xi'an, Tang dynasty. Ceramic, *sancai* ware (three color glazes); h. 36⅜ in. overall. Gift of various donors to the department of Asian Art, by exchange 2000.118.1–2

80. *Streams and Mountains without End,* about 1127–1150. China, Early Jin dynasty. Handscroll; ink and slight color on silk; 13⅞ x 83⅞ in. Gift of the Hanna Fund 1953.126

81. Wang Mian (Chinese, 1286–1359). *A Prunus in the Moonlight,* 1300s. China, Yuan dynasty. Hanging scroll; ink on silk; 64⅞ x 37¼ in. Leonard C. Hanna Jr. Fund 1974.26

82. Wen Zhengming (Chinese, 1470–1559). *Imperial Gift of an Embroidered Silk: Calligraphy in Running Style,* about 1525. China, Suzhou, Ming dynasty. Ink on paper; 135⅞ x 36⅞ in. John L. Severance Fund 1998.169

83. Giuseppe Castiglione (Lang Shining) (Italian, 1688–1766). *Inauguration Portraits of Emperor Qianlong, the Empress, and Eleven Imperial Consorts,* 1736. China, Qing dynasty. Handscroll; ink and color on silk; 20⅞ x 271¼ in. John L. Severance Fund 1969.31

84. Zhu Da (Chinese, 1624–1705). *Fish and Rocks.* China, Qing dynasty. Handscroll; ink on paper; 11½ x 62 in. John L. Severance Fund 1953.247

85. *Flame-Style Storage Vessel,* about 2500 BC. Japan, Middle Jōmon period. Earthenware with incised and applied decoration; h. 24 in. John L. Severance Fund 1984.68

86. *Buddha of the Future,* late 600s. Japan, late Asuka–early Nara period. Cast bronze, incised, with traces of gilding; h. 18 in. John L. Severance Fund 1950.86

87. *Shinto Deities,* 800s–900s. Japan, Heian period. Wood with traces of polychromy; h. 20⅜ in. Leonard C. Hanna Jr. Fund 1978.3.1–2

88. *Buddhist Tabernacle,* late 1100s. Japan, Heian period. Black lacquer over a wood core with hemp cloth covering, gold paint, cut gold leaf, ink, mineral pigments, and attached metalwork; h. 63 in. John L. Severance Fund 1969.130

89. *Zen Master Hottō Kokushi,* about 1286. Japan, Kamakura period. Wood with hemp cloth, black lacquer, and iron clamps; h. 36 in. Leonard C. Hanna Jr. Fund 1970.67

90. *Storage Jar, Echizen Ware,* 1400s. Japan, Muromachi period. Stoneware with natural ash glaze; h. 19⅝ in. John L. Severance Fund 1989.70

91. *Plate with Persimmon Branch Design: Old Kutani Ware, Aode (Green), Kutoni Style,* late 1600s. Japan, Edo period. Porcelain with overglaze decoration; diam. 13⅜ in. Severance and Greta Millikin Collection 1964.245

92. *Bell,* 1200s. Korea, Goryeo period. Cast bronze with incised inscription; h. 9⅛ in. John L. Severance Fund 1992.118

93. *Standing Buddha Amitabha,* 800s. Korea, Unified Silla period. Gilt bronze; h. 10 in. Leonard C. Hanna Jr. Fund 1988.34

94. *Amit'a Triad,* 1400s. Korea, Joseon period. Bronze with traces of gilding; h. 16 in. Worcester R. Warner Collection 1918.501

95. *Storage Jar: Punch'ong Ware,* 1400s. Korea, Joseon period. Stoneware with incised, stamped, and slip-inlaid decoration under a clear glaze; h. 14¾ in. John L. Severance Fund 1963.505

96. *Standing Buddha,* 400s. India, Sarnath, Gupta period. Sandstone; h. 30 in. Purchase from the J. H. Wade Fund 1943.278

97. *Head of Buddha,* 400s. India, Mathura, Gupta period. Red mottled sandstone; h. 12 in. John L. Severance Fund 1963.504

98. *Shiva Nataraja: Lord of the Dance,* 11th century. South India, Chola period. Bronze; h. 43⅞ in. Purchase from the J. H. Wade Fund 1930.331

99. *Lovers,* 11th century. India, Madhya Pradesh, Khajuraho style. Red sandstone; h. 29⅛ in. Leonard C. Hanna Jr. Fund 1982.64

100. *Standing Buddha.* Kashmir, cast between 998 and 1026. Brass; h. 38⅝ in. John L. Severance Fund 1966.30

101. *Green Tara,* about 1250–1300. Tibet. Color on canvas; 20 x 17⅝ in. Purchase from the J. H. Wade Fund by exchange, from Doris Wiener Gallery 1970.156

102. *Krishna Govardhana,* about 500–550. Cambodia, early Phnom Da style, Pre-Angkorean period. Gray limestone; h. 96⅛ in. John L. Severance Fund 1973.106

103. *Standing Buddha,* about 600s. Thailand, Mon-Dvaravati period. Sandstone; h. 52¼ in. Leonard C. Hanna Jr. Fund 1973.15

104. *Seated Figure,* about 300 BC–AD 500. Mexico, Oaxaca, Zapotec style. Earthenware; h. 12¾ in. Gift of the Hanna Fund 1954.857

105. *Front Face of a Stela,* about 692. Guatemala, El Perú site, Maya style. Limestone; 108⅛ x 71⅞ in. Purchase from the J. H. Wade Fund 1967.29

106. *Carved Vessel,* about 600–900. Honduras, Classic Ulúa Valley style. Marble; h. 10⅝ in. John L. Severance Fund 1990.9

107. *Ballgame Yoke,* about 600–900. Mexico, Classic Veracruz style. Serpentine with traces of cinnabar; h. 16¾ in. Purchase, Leonard C. Hanna Jr. Bequest 1973.213

108. *Lidded Bowl with Modeled Iguana,* about 300–1100. Costa Rica, Guanacaste-Nicoya style. Earthenware with colored slip; h. 16 in. Norman O. Stone and Ella A. Stone Memorial Fund 1995.72.a–b

109. *Plaque with Reptilian Being,* about 700–900. Panama, Coclé Province, Sitio Conte site, Grave 26, Deposit XVI. Hammered and embossed gold; 9⅞ x 10½ in. Gift of Mrs. R. Henry Norweb, Mrs. Albert S. Ingalls, and additions from the John L. Severance Fund 1952.459

110. *Plaque,* about 400–300 BC. Peru, Lambayeque River Valley, probably Chongoyape site, Chavín style. Cut and hammered gold-silver-copper alloy; 8⅝ x 4¼ in. Purchase from the J. H. Wade Fund 1946.117

111. *Female Figure,* about 100 BC–AD 600. Peru, South Coast, Nasca style. Earthenware with colored slips; h. 11¼ in. John L. Severance Fund 1997.184

112. *Figure in a Litter,* about 500–900. Peru, Wari style. Earthenware with colored slips; h. 10¼ in. Leonard C. Hanna Jr. Fund 1997.1

113. *Mask,* 1800s. North America, Pacific Northwest Coast, Tlingit style. Alder wood; h. 8¼ in. Purchase from the J. H. Wade Fund 1979.83

114. Nancy Youngblood (American, born 1955). *Carved Vessel,* 1994. North America, Santa Clara Pueblo, New Mexico. Earthenware; diam. 8⅞ in. James Albert and Mary Gardiner Ford Memorial Fund 1994.199

115. Antonio Pollaiuolo (Italian, 1431/ 32–1498). *Battle of the Nudes,* about 1470–75. Engraving; 16½ x 23¾ in. Purchase from the J. H. Wade Fund 1967.127

116. Rembrandt van Rijn (Dutch, 1606– 1669). *The Three Crosses (Christ Crucified),* 1653–60. Drypoint and engraving, fourth state; 14¾ x 17⅜ in. Bequest of Ralph King and Purchase from the J. H. Wade Fund 1959.241

117. Edvard Munch (Norwegian, 1863– 1944). *Melancholy (Evening: On the Beach),* about 1896. Woodcut with hand coloring; 14⅞ x 17¾ in. Gift of Mrs. Clive Runnels in memory of Leonard C. Hanna Jr. 1959.82

118. Michelangelo Buonarroti (Italian, 1475–1564). *Study for the Nude Youth over the Prophet Daniel on the Sistine Chapel Ceiling,* 1510–11. Red chalk and black chalk on beige laid paper; 13¼ x

9¼ in. Gift in memory of Henry G. Dalton by his nephews George S. Kendrick and Harry D. Kendrick 1940.465.a

119. Albrecht Dürer (German, 1471– 1528). *Arm of Eve,* 1507. Point of brush and gray and black wash, brush and gray and black wash, heightened with white gouache on blue laid paper; 13⅛ x 10½ in. Accessions Reserve Fund 1965.470

120. Jean-Honoré Fragonard (French, 1732–1806). *Invocation to Love,* about 1781. Brush and brown wash over graphite, over squaring in graphite, on cream laid paper; 13⅞ x 16⅜ in. Grace Rainey Rogers Fund 1943.657

121. Jasper Johns (American, born 1930). *Ten Numbers,* 1960. Charcoal with graphite on ten sheets of white wove paper; 13 x 10⅞ in. (average dimensions). John L. Severance Fund 2001.10.a–j

122. William Henry Fox Talbot (British, 1800–1877). *Articles of Glass,* 1843. Salted paper print from calotype negative; 5¼ x 6 in. Andrew R. and Martha Holden Jennings Fund 1992.121

123. Lázló Moholy-Nagy (American, born Austria-Hungary, 1895–1946). *Eiffel Tower, Paris,* 1925. Gelatin silver print; 11¼ x 8¼ in. Dudley P. Allen Fund 1997.144

124. Thomas Struth (German, born 1954). *San Zaccaria, Venice,* 1995. Chromogenic process color print; 71¾ x 90⅞ in. Louis D. Kacalieff M.D. Fund 1996.13

125. *Cloth with Procession of Figures,* 100 BC–AD 200. Peru, South Coast, Paracas Peninsula(?), Nasca style. Field: plain weave, pigment, cotton; border: plain weave, camelid fiber; 34 x 117⅛ in. The Norweb Collection 1940.530

126. *Child's Coat,* 700s. Central Asia, Sogdiana. Outer fabric: weft-faced compound twill, silk; lining: damask, silk; 18⅞ x 32½ in. Purchase from the J. H. Wade Fund 1996.2.1

127. *Kayasha,* 1403–24. China, Ming dynasty. Embroidery and appliqué; silk and gold thread on silk gauze ground; 47 x 119 in. Leonard C. Hanna Jr. Fund 1987.57

128. *Curtain,* 1400s. Islamic, Spain, Nasrid period. Two combined structures, twill and plain weave (lampas); silk; 172⅝ x 107⅛ in. Leonard C. Hanna Jr. Fund 1982.16.a–b

129. *Ceremonial Patolu, with Four Great Elephants,* mid-1800s. India, Gujarat. Plain weave, double ikat; silk, cotton; 47¼ x 187⅛ in. Gift of the Textile Art Alliance 1990.92

130. *Shawl with Pictorial East-West Scenes,* 1867. France, Lyon. Compound weave; silk; 66½ x 140½ in. Gift of William T. Higbee 1928.627